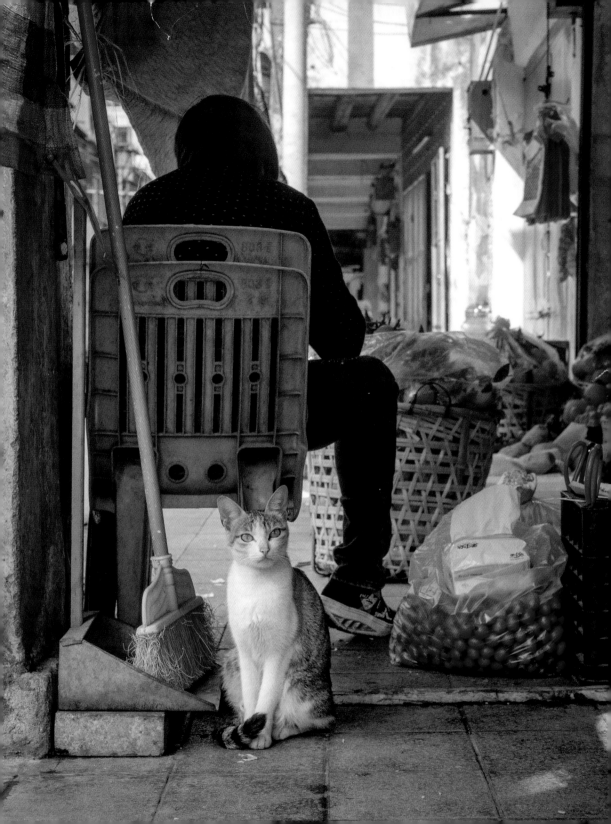

SHOP CATS
OF
CHINA

Photographs by Marcel Heijnen
Haiku and cat stories by Ian Row

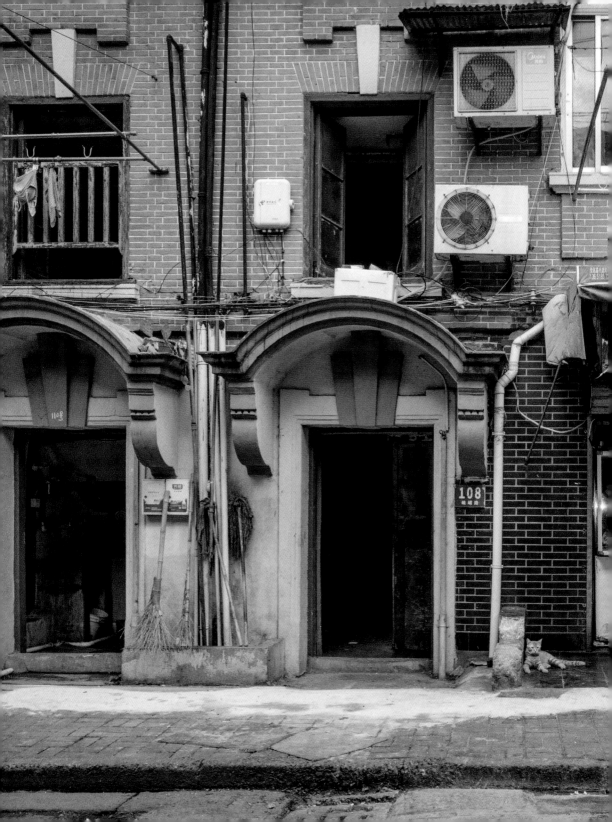

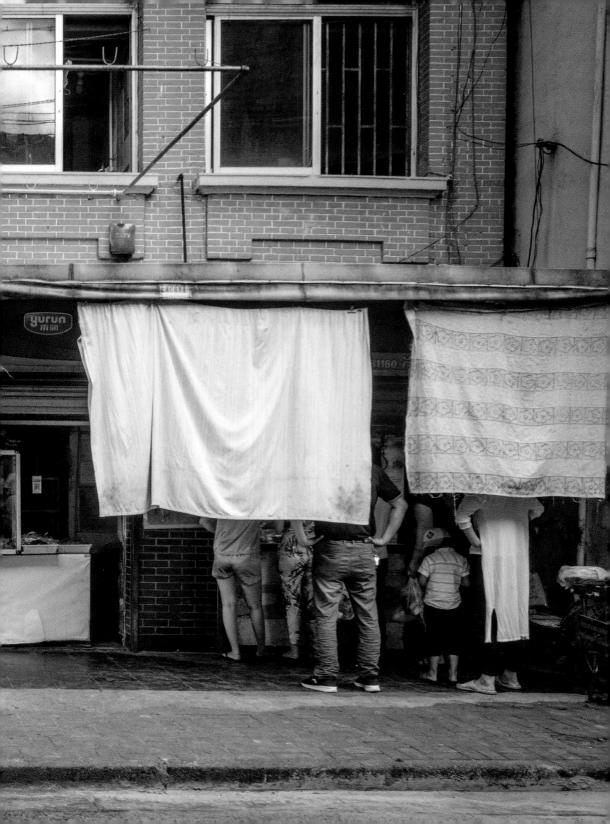

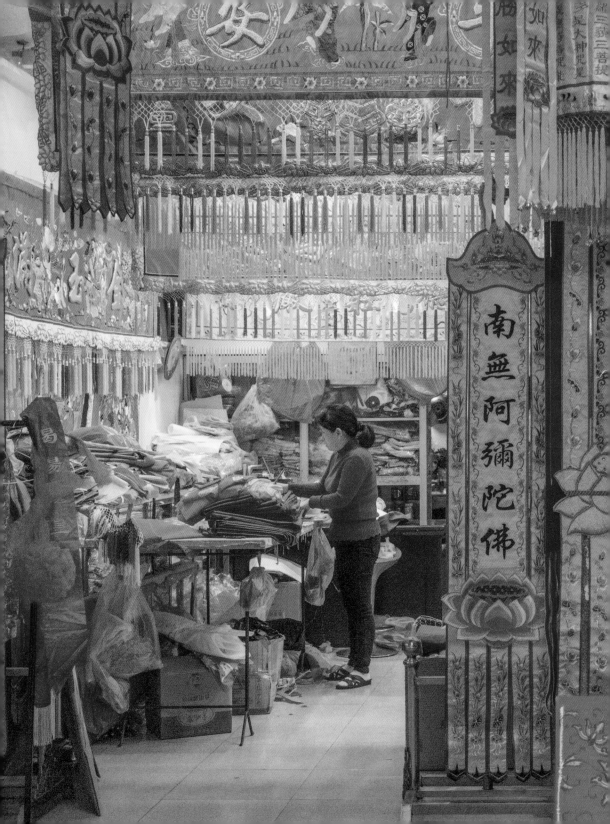

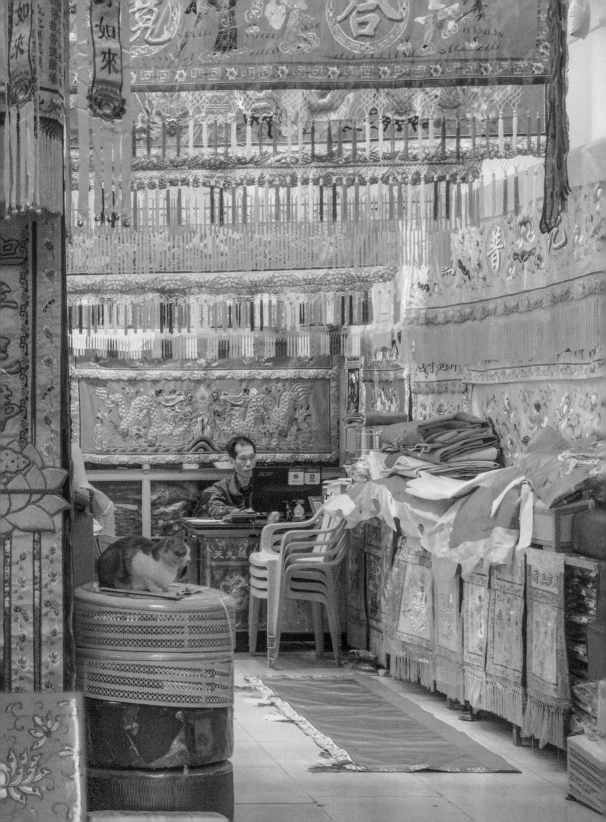

CULTURE, CLASS & CAT FEVER

*Meet the characters responsible for
China's most charming retail therapy*

by Catharine Nicol

There is no denying the power of cats. Fluffy or sleek, lithe or lazy, simply by being themselves they have kept us humans enraptured for centuries, eventually becoming universal celebrities across the world, east and west, real and digital.

Humans have always been under the magic spell of *Felis silvestris catus*. We may think we have tamed them, but isn't it more likely the cat domesticated itself for the advantages of shelter and dinner – and eventually the all-important Instagram infamy?

The Chinese character for cat (猫) is made up of 'four-legged animal' on the left, with the right radical related to crops, linking how their useful rodent-catching instincts kicked in as man discovered agriculture. The right radical, the phonetic indicator, is pronounced 'mao', delightfully like a cat's 'meow'.

THE STRANGELY CAT-FREE CHINESE HOROSCOPE

In Chinese culture, cats have always been known for their mysterious ways – sensing spirits, scaring ghosts and bringing good luck. Given their national popularity, the million-yuan question is: why isn't the cat one of the animals of the Chinese horoscope?

One legend tells how the rat didn't wake the cat on the day of the race to the Jade Emperor, which determined who would be part of the zodiac. Another recounts how the rat pushed the cat off the ox's back while crossing a river during the race. More realistically, perhaps, at the time of the first emperor Huangdi in 2736 BC, when the zodiac was created, cats weren't yet omnipresent across China.

Whatever the answer, cats and rodents have been mortal enemies since time immemorial, which is why cats are such valued members of China's dried-goods shops. Shop owners believe that just having a cat in residence, whether or not it is fit enough, or willing enough, to fulfil its mousing role, is enough to keep rodents at bay.

STALKING THROUGH THE DYNASTIES

Across the world, humans' love of cats goes back centuries and it is no different in China. Archaeological digs in the northwestern Shaanxi province show evidence of human–cat cohabitation dating back to the early Neolithic period (7,000–5,000 BC).

Chinese literature depicts cats at the time of the Western Zhou dynasty (1045–771 BC); later, during the Eastern Zhou dynasty (770–256 BC), Confucius' tome *The Book of Songs* mentions felines as part of the fauna in China. It was then that the infamous Empress Wu, China's only female ruler for more than two millennia, was in power. Allegedly a 'crazy cat lady', perhaps she was one of the world's first.

Back then cats were prized as companions in high-class households and frequently the subjects of paintings and poetry, the elegant equivalent of today's social media. Rich owners would spoil their pets with the freshest fish and finest treats. Interestingly, during the Song dynasty (960–1279) marmalade cats were in vogue and favoured as pets, while long-haired cats were relegated to the role of functional mousers.

Song-dynasty poet Lu You loved cats, especially as they chased away the mice that threatened to chew through his priceless collection of books. In his day, welcoming a new cat into the home was seen as an event to celebrate, and friends and acquaintances would arrive to meet the new member of the household bearing salt – an expensive luxury at the time – as a gift.

You may be surprised to hear that cats had an influence on the economic reform of China following the Cultural Revolution. As Deng Xiaoping, the 'Architect of Modern China', observed when weighing up planned versus market economies: 'It doesn't matter if a cat is black or white; as long as it catches mice, it is a good cat.' Clearly, cats have been good for both national and shop economies for a long time.

CATFLUENCERS

Today, China is as much in the paws of cat-fever as the rest of the world. The cat-based economy is booming and the marketing power of cats is unstoppable. Alongside the cat cafés and cute accessories, digitally shared photos, memes, gifs, apps, games and social-media personalities all fuel the feline phenomenon on a daily basis.

Beijing's Palace Museum has around 200 real mousers keeping the old wooden building free from rats, while Guanfu Museum actually employs cats as official directors. This previously little-known art museum is now a fan favourite, thanks to the daily gathering of over 30 cats for their courtyard lunch. There is plenty of catmobilia for sale in the museum's store, and the directors' Weibo account has many thousands of followers.

Cat influencers include China's Snoopybabe (@snoooopybabe), as well as Erdou and Guazi, who are popular on Douyin (the Chinese version of TikTok). Hong Kong's Brother Cream (@creambrother_thecat) has his own PR team, cat-food brand and even a celebrity cat-wife. Popular catfluencers are stress-busters for their followers and owners in high-pressure China. Depending on their popularity, the products and services they endorse – from electronic grooming devices, plush beds and fun slides to luxury cat hotels where your pet can spend time at a beauty salon, getting a massage treatment before a photoshoot – earn the RMB necessary for even more blinged-up accessories and luxurious five-star TLC.

CAPRICIOUS YET AUSPICIOUS EMPLOYEES
Whether cats come across as cute and friendly or haughty and entitled, we love how one moment they display human traits and Mona Lisa expressions and the next pour themselves into strange shapes or get into awkward scrapes.

Turn your back on them for a minute, and a valuable item might fall mysteriously to the floor. Scoop them up for cuddles and they slither out of your arms like water. Give them a toy and they prefer the box it came in.

China's shop cats are no different. Will they stretch out a velvet paw or a flesh-tearing claw? Will they purr in delight or throw a hiss your way? Will they rub their heads on your hand or take a needle-sharp bite out of your finger? Most likely, all of the above – and probably within the space of a minute.

Cats' trump cards are, of course, that they just don't care. Ever-changing moods and indifference in a fellow human might spell the end of a relationship, or indeed employment, but with cats we just can't help but go back for more.

CATS IN 2D

Within these paper-and-pigment pages, you'll find China's shop cats wield a real power of their own. Marcel Heijnen has travelled far and wide across China in his search for shop cats, and found many traditional family-run shops that welcome feline employees. The cats may be mostly confined to the cluttered worlds of dusty retail, but they are happy to lord it over their mini-fiefdoms, occasionally deigning to defer to the customers. Little do they know, as they gaze into or ignore Marcel's lens, how they now also mesmerize a much, much wider audience.

The high-tech, high-decibel super-city of Shanghai is, surprisingly, still home to a number of shops with cats on the payroll, despite its headlong rush into everything modern and new. Marcel anticipates, however, that as the old neighbourhoods become increasingly gentrified, the shop cat will be relegated to the city's historic past.

In Guangdong province to the south, vast areas of old streets and the slower pace of life in the capital city Guangzhou have helped preserve the shop-cat culture – for now. Marcel's favourite discovery in the province was the small town of Shantou. He came upon it by happy accident, alighting from the high-speed train from Fujian on a whim, and spent three days enraptured by the mazes of early 20th-century buildings. In place of malls and high-rises, the appealingly ramshackle shops often housed a still-thriving trade of dried goods on the inside.

And where you get dried goods, you get shop cats ...

... or rats.

A NOTE ON THE HAIKU

The traditional (Japanese) haiku is made up of 3 lines and 17 *sounds*. Sounds in the Japanese language are not equivalent to syllables in English. For example, the word 'haiku' is two syllables in English (*hi-ku*), but three *sounds* in Japanese (*ha-i-ku*). So the 5–7–5 syllable rule is effectively a Western imposition and places excessive emphasis on form. What is essential in writing haiku is the development – some would say the 'unfolding' – of a story. The haiku in this book, therefore, pay homage to the traditional short–long–short format, as opposed to following a strict 5–7–5 structure, while staying true to the spirit of the poetic form.

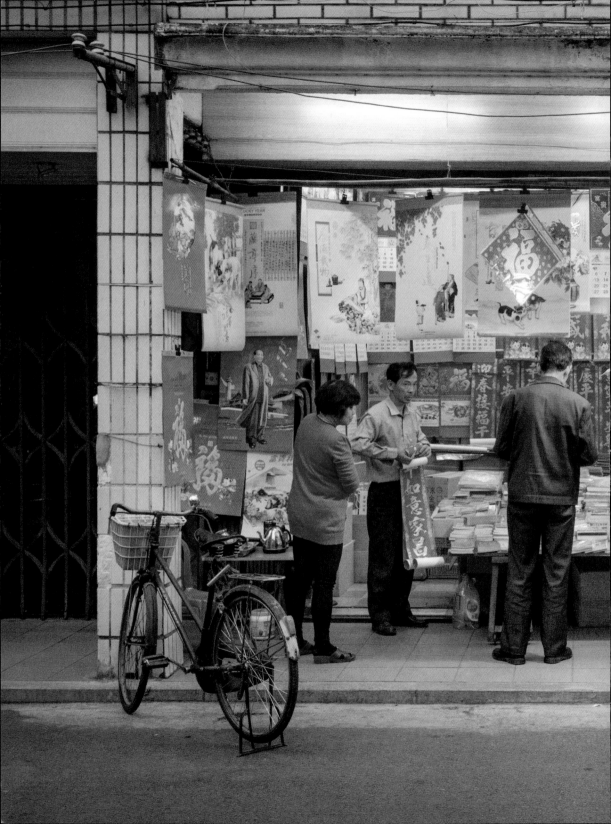

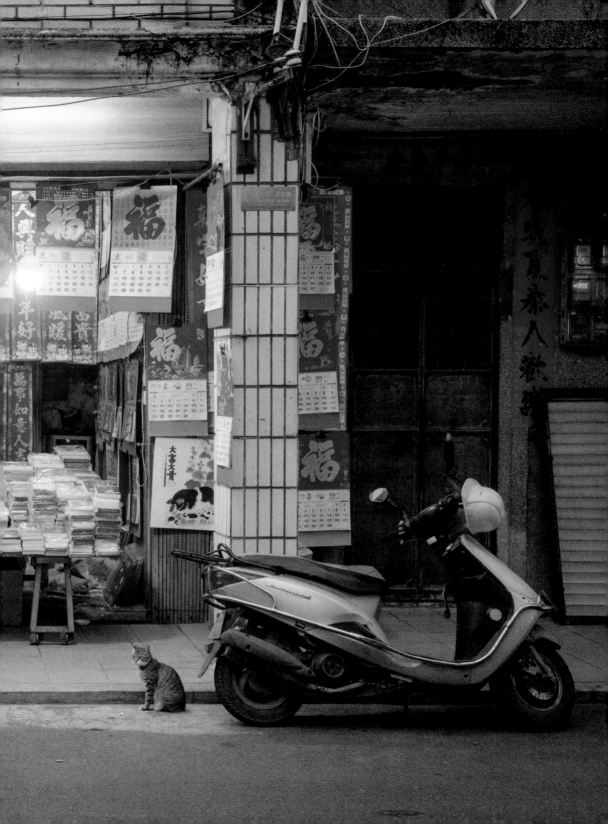

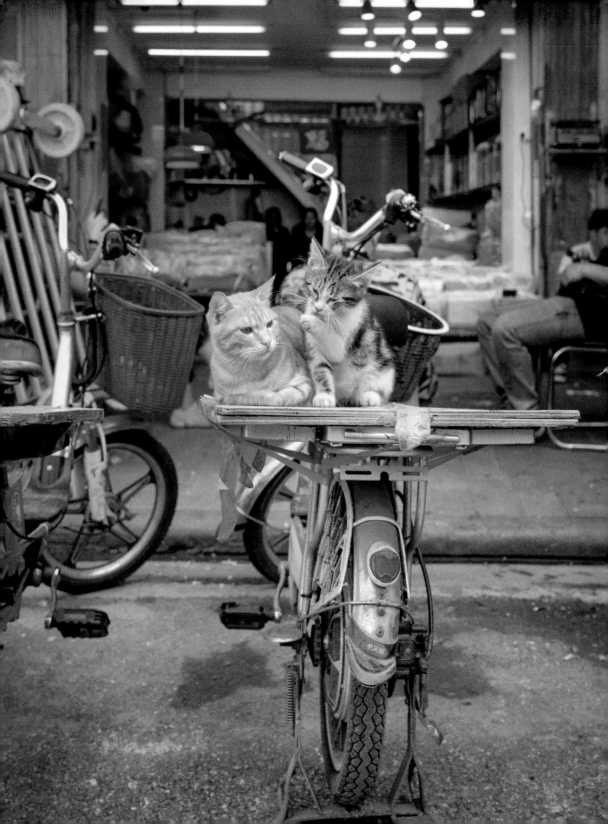

MADE IN CHINA

by Marcel Heijnen

In 2016 I launched the first photo book in the Chinese Whiskers series – *Shop Cats of Hong Kong* – filled with photos mostly shot in Hong Kong's Sai Ying Pun district, where I was living at the time. Many exhibitions followed and the series went viral online, with articles written about it from New York to Paris, Amsterdam to Tokyo.

Even before that first book about Hong Kong's shop cats was released, I wondered if the phenomenon could be a thing in mainland China, too. So I began travelling and exploring with my camera in hand. Starting in Guangzhou, the project took me to around 10 different cities in China, some with more shop cats than others, but each one was a joy to explore. The series featured in this book took about four years and numerous trips to complete, and it was wonderful to acquaint myself with the country. I have fond memories of exploring the old streets and neighbourhoods, and taking in the view from high-speed trains and local buses.

The cat is essential for the photo series, but sometimes a feline just becomes an excuse to shoot a particular shop – an ice-breaker that gives me a reason to smile at a shop owner and have a chat before I press the shutter. In China, this also often resulted in getting invited in for a few cups of tea by the shop owners.

China is on the rise economically and in terms of its importance in the world, and this is very apparent in the larger cities where some, or even most, of the old areas have had to make way for new office and residential buildings and shopping malls. It was in these old areas that I found my feline subjects – areas that may not be around in a few years, all the more reason to create a photographic record of them.

I hope you will enjoy looking at the photographs as much as I enjoyed taking them. Most of the cats are the kings and queens of their retail outlets, and very obviously so. Others might be incredibly hard to spot – go find them!

P.S. No animals were harmed during the making of this book.

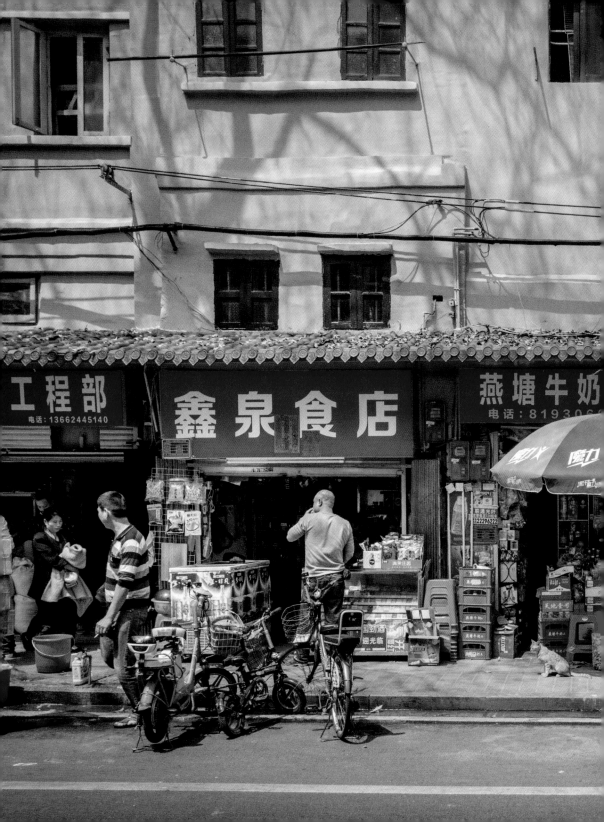

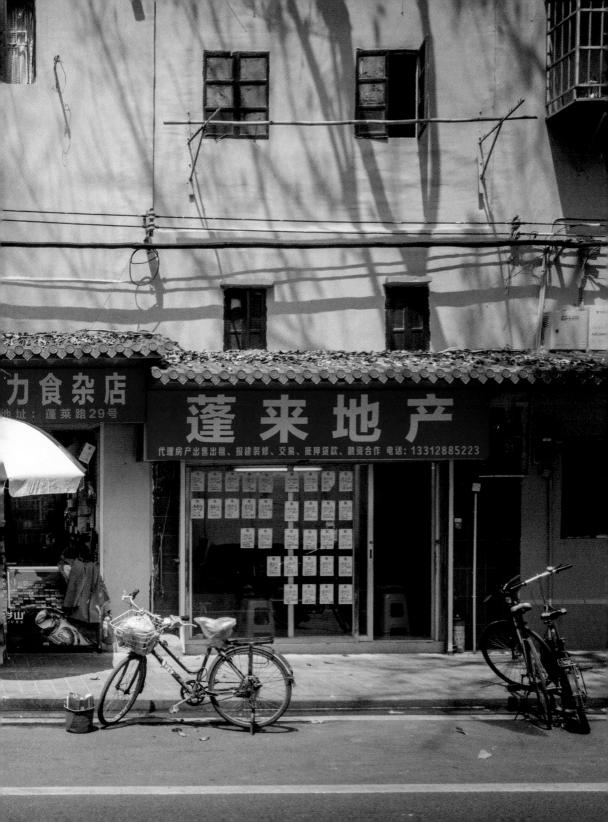

Man has four girlfriends
Don't believe what you read
or what you see

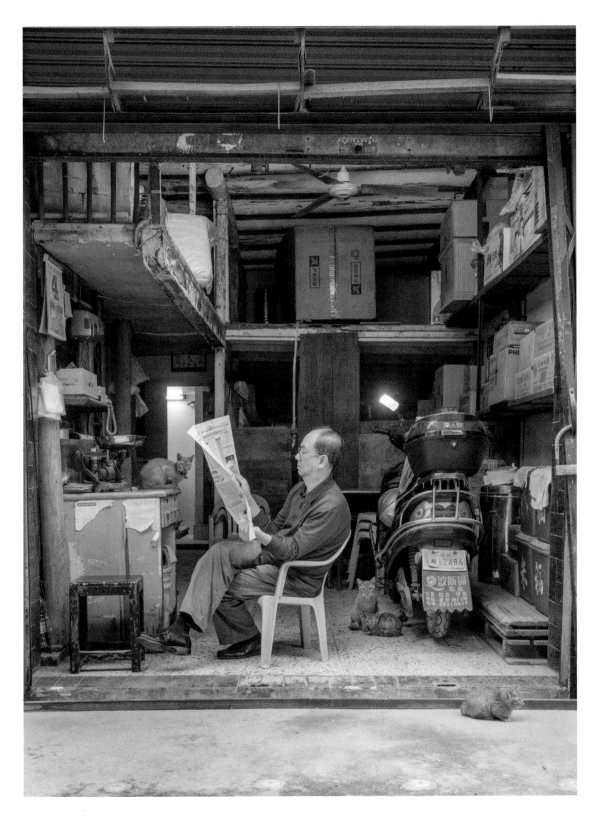

Snake, dragon, monkey
sheep, dog, pig ... Why is there no
Year of the Cat?

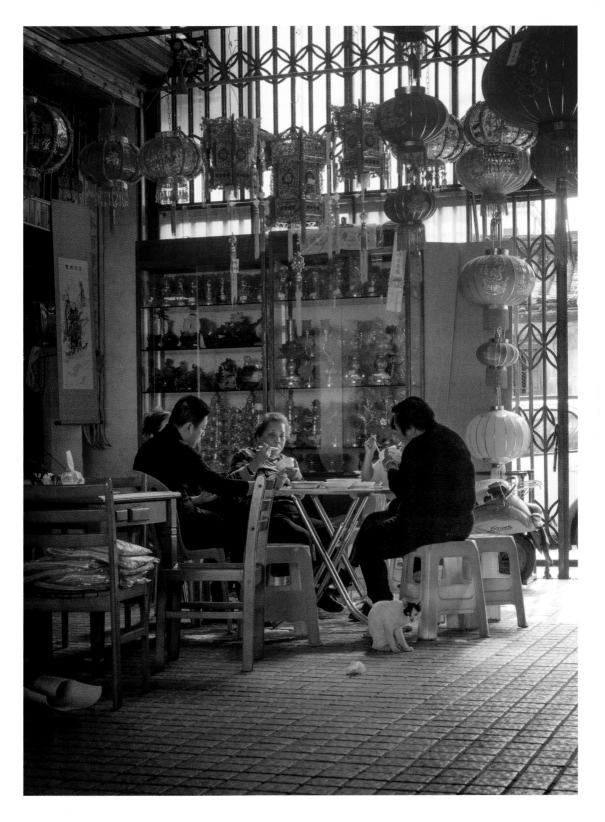

Three generations
Grandfather, my master, me
Family business

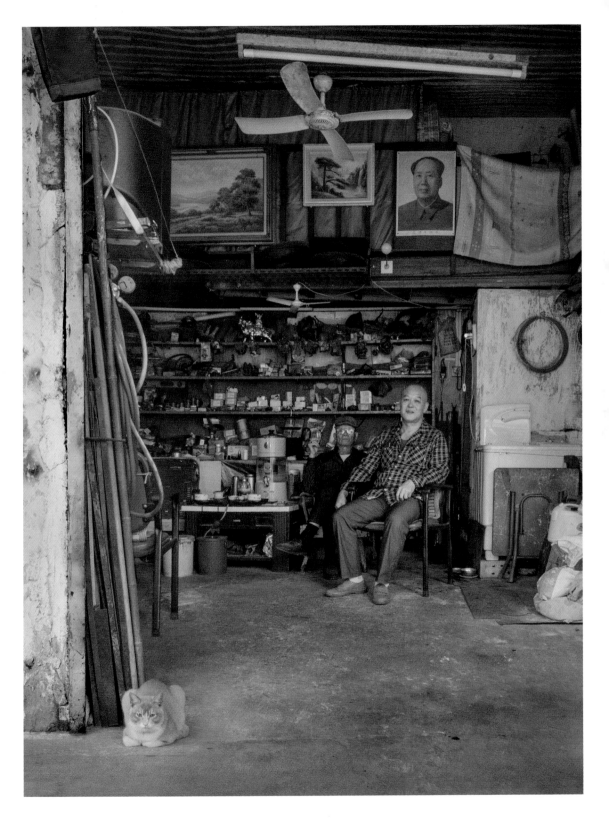

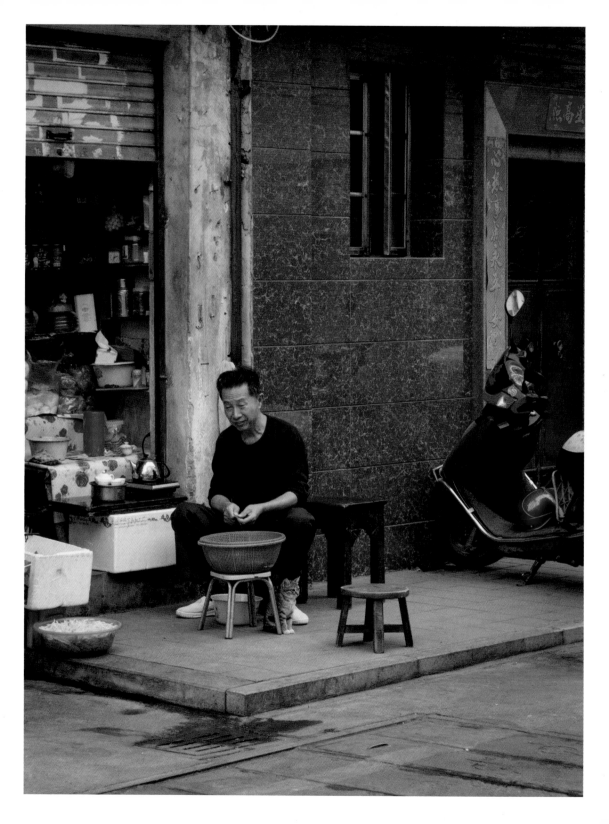

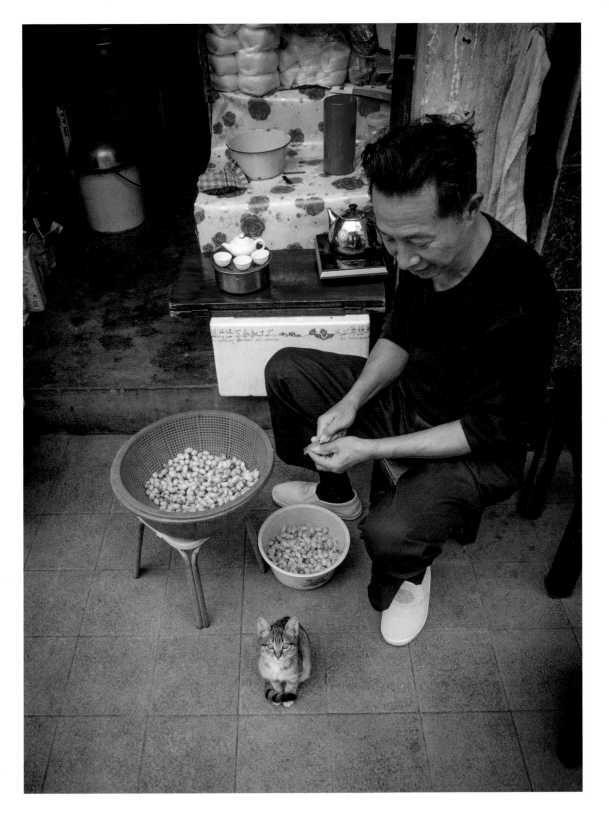

I've learned to be shy

without a mother to make me bold

The world is my teacher

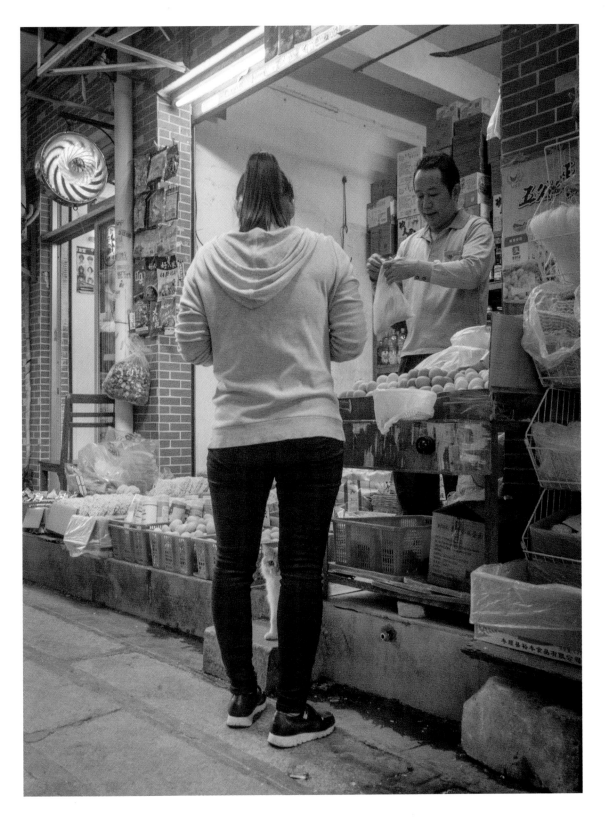

She's all I got

I'm going to miss her

when the time comes

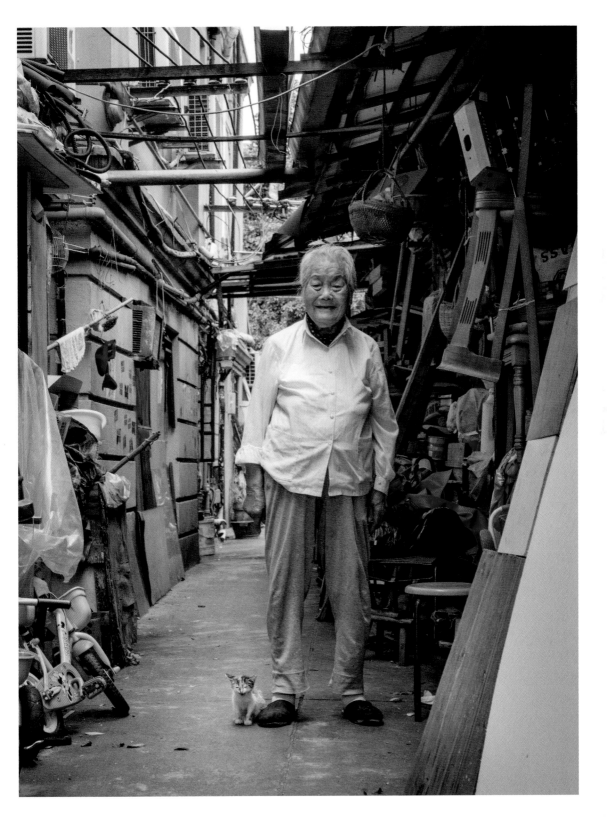

An invitation

A seat at the table

Tea for two, or three

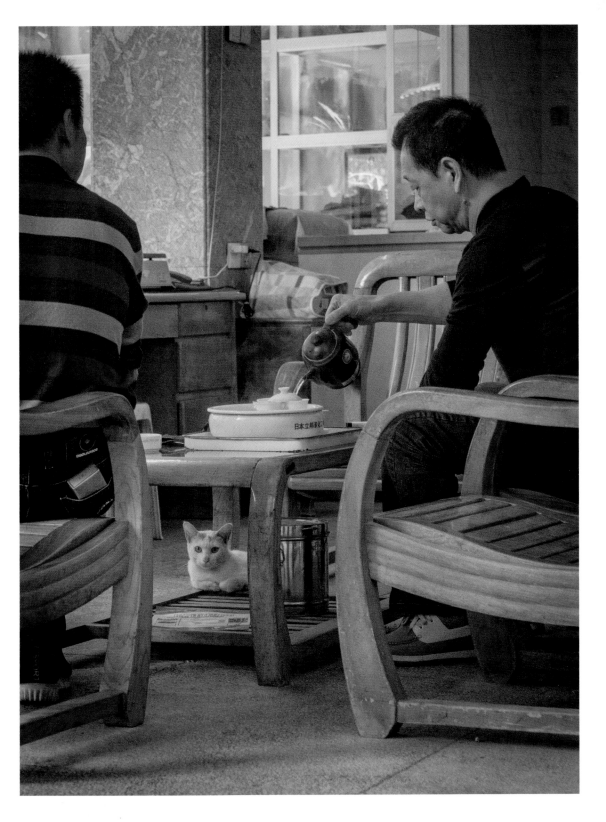

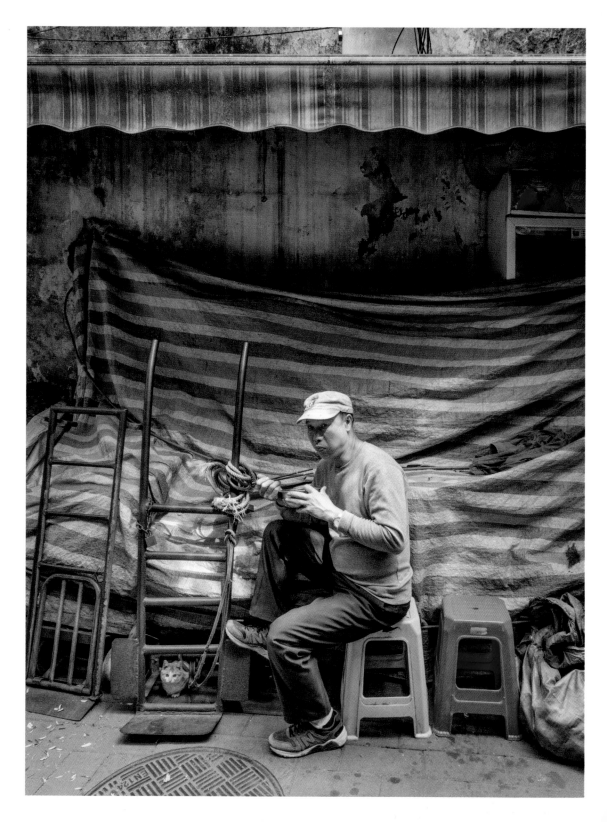

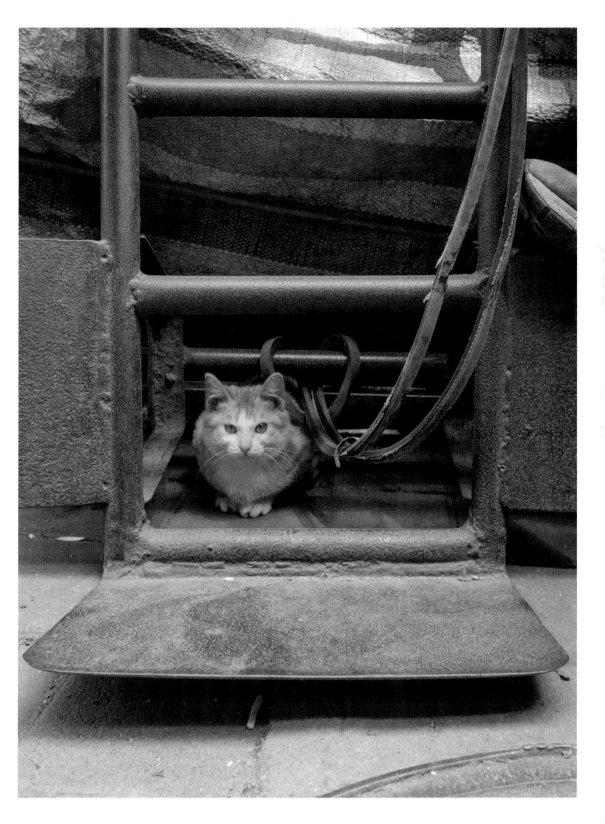

Man regales cat
with tales of his youth, keeps cat
on the edge of his tail

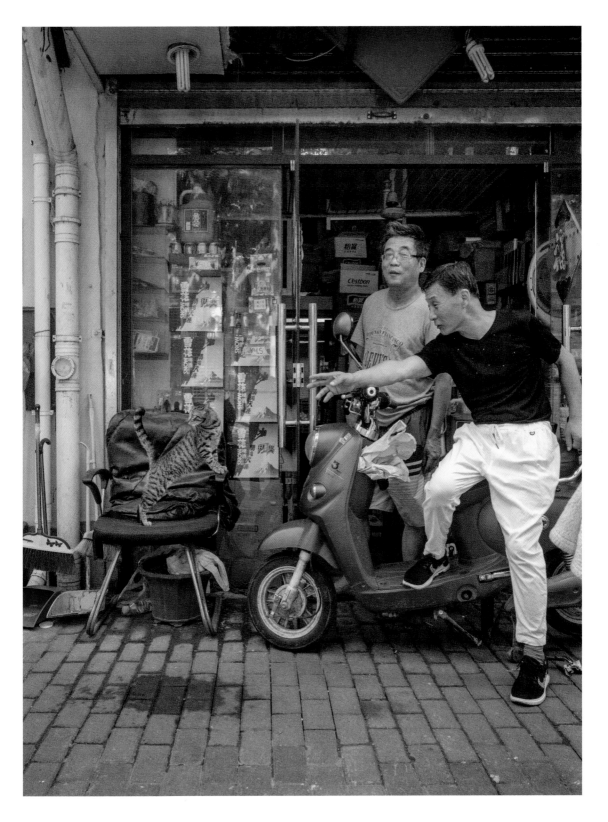

Man and bicycle
stop, a cat stands still – they let
the world pass them by

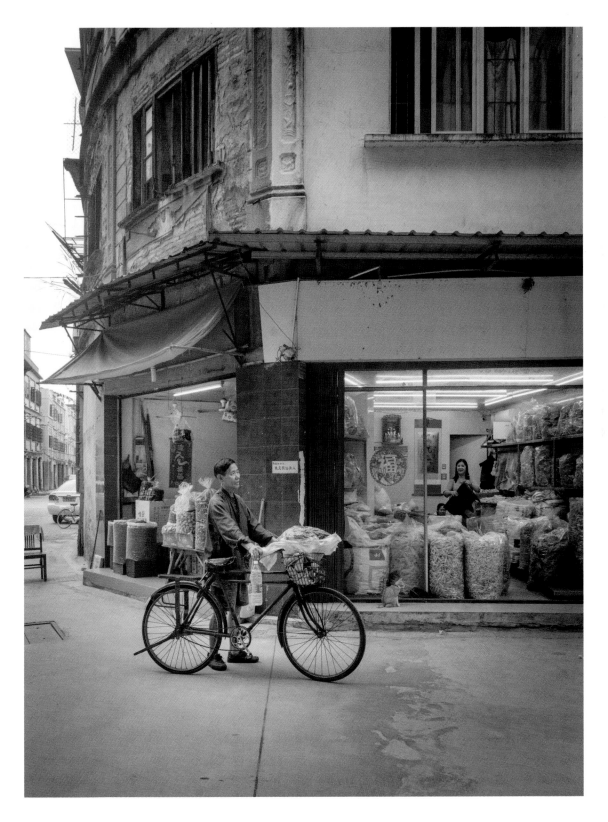

Move to the city,
I said. Life is better but the
living is twice as hard

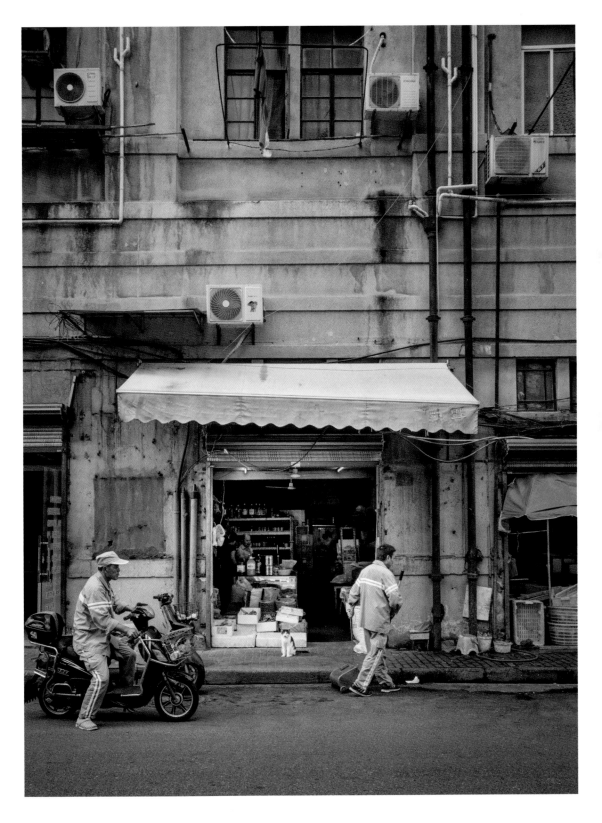

Sleepy days … when time
feels like it's standing still
But blink, and you're old

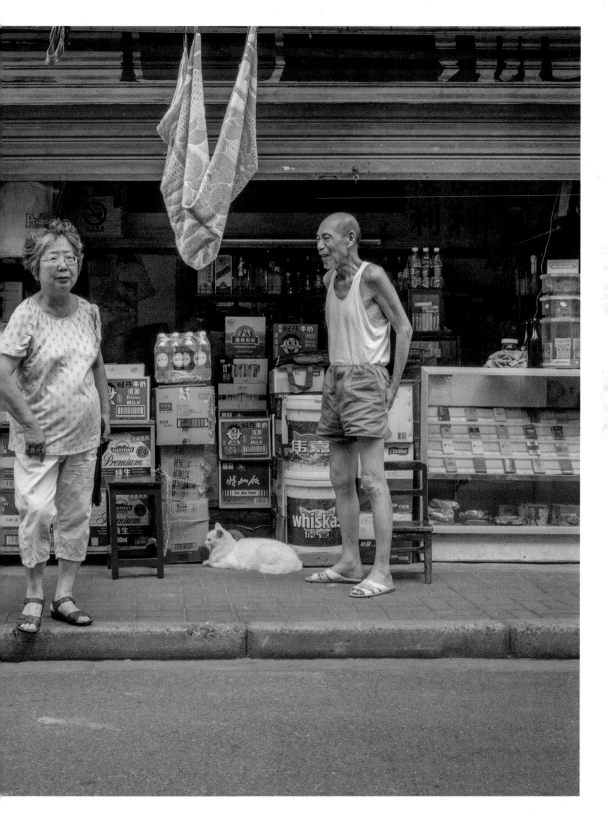

She's not my girlfriend,
says the man. Yes, she's pretty
but just not my type

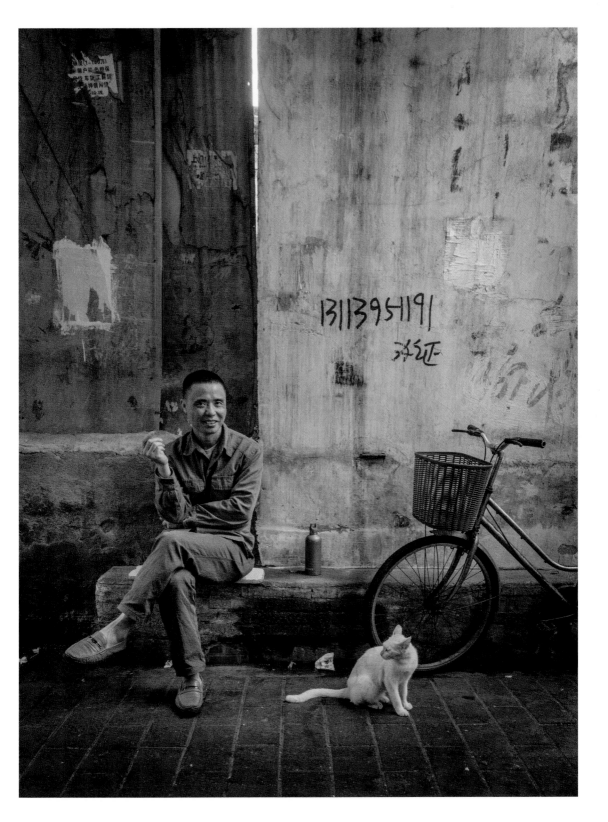

Treats me like a child ...
I'm eleven! Old enough
to be his father

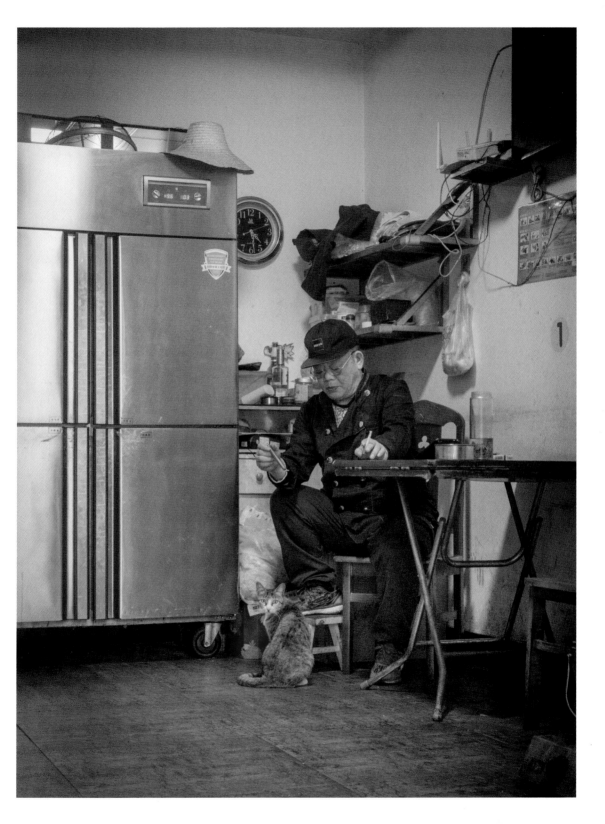

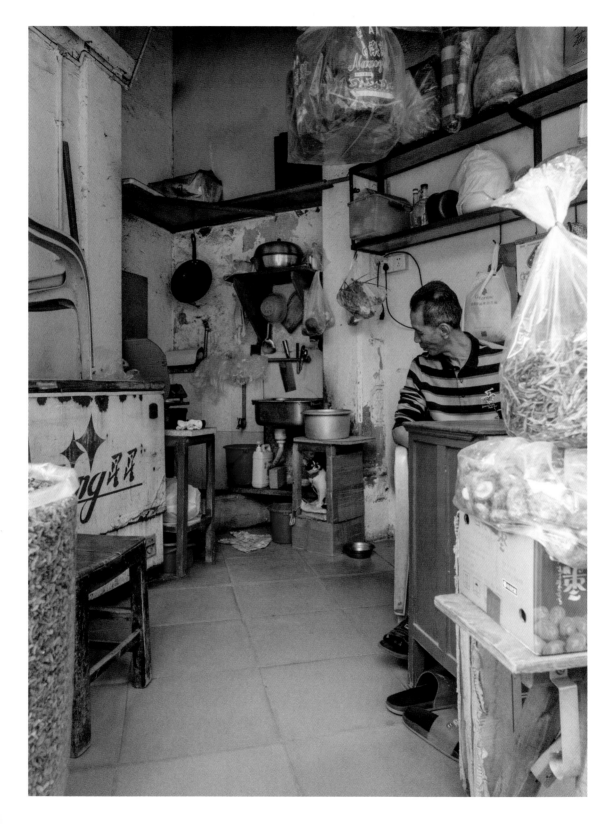

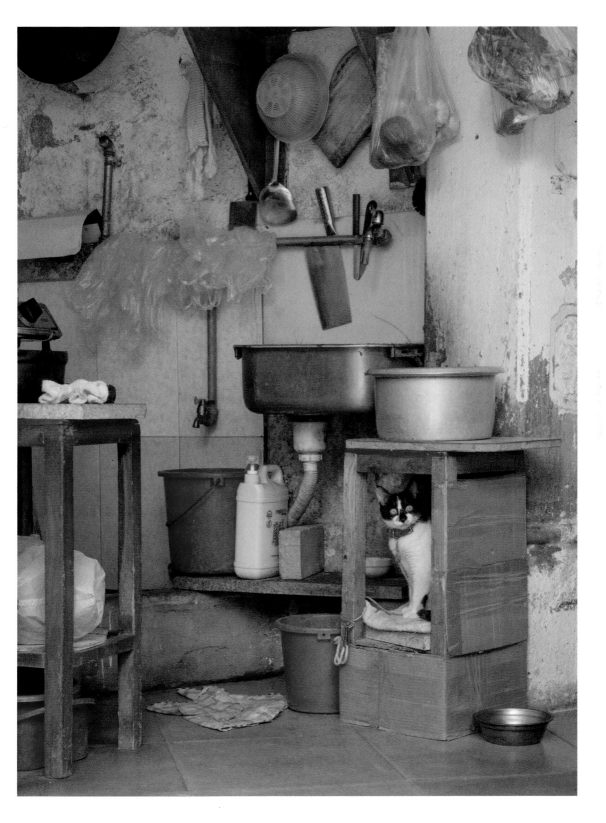

I know what you're
thinking – how did I get up here?
Magic!

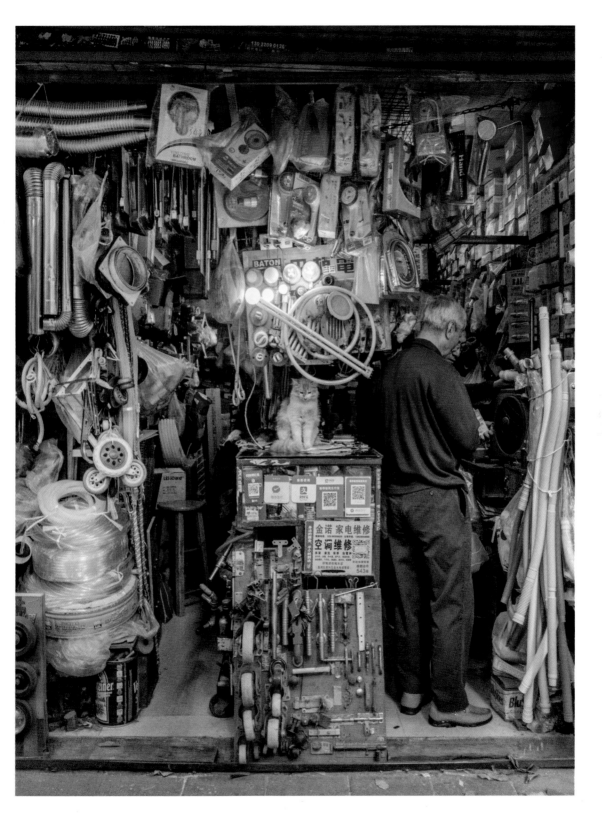

Old man reminisces

someone else's memories

It's polite to look away

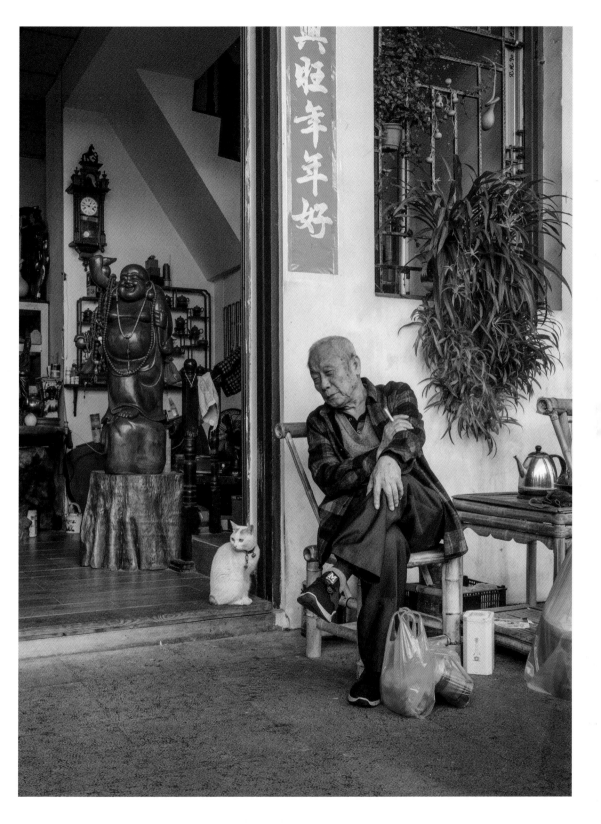

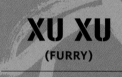

XU XU
(FURRY)

The Wanderer

No one really knows where Xu Xu came from. In fact, very little is known about him. He's the type of cat that likes to keep his cards close to his furry chest. One day, he just shows up. The owner of the shop was captivated by him – so striking in his handsome coat, with those green eyes that spoke of many lives lived before. She never thought of keeping a cat, but Xu Xu immediately found his way into her heart and home. So he stayed. No questions asked.

Interestingly enough, there isn't a contract between them but an understanding. The owner had sensed a restlessness in Xu Xu. She knew he liked it here, but that he wouldn't stay in one place for too long. She told herself not to get too attached because one day, without warning, he will up and go. Because a cat is like that ... he's got places to go, cats to see.

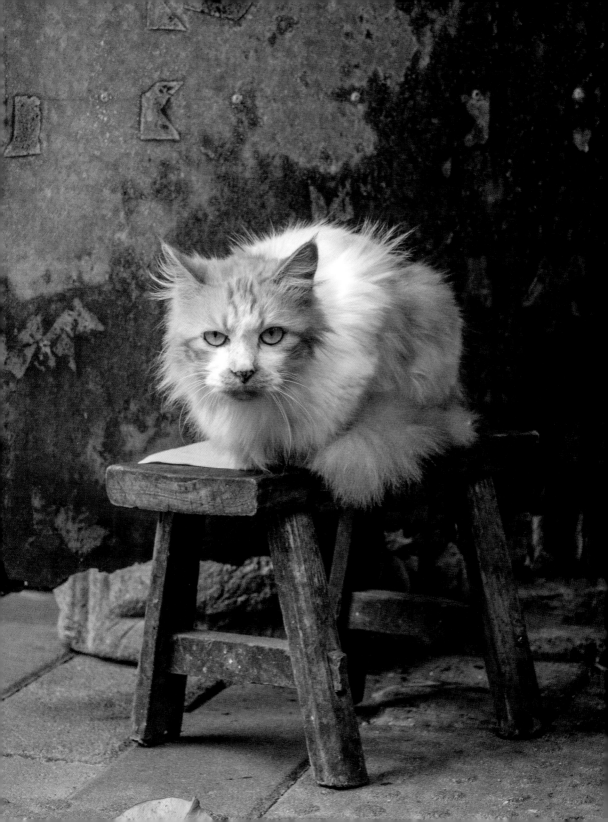

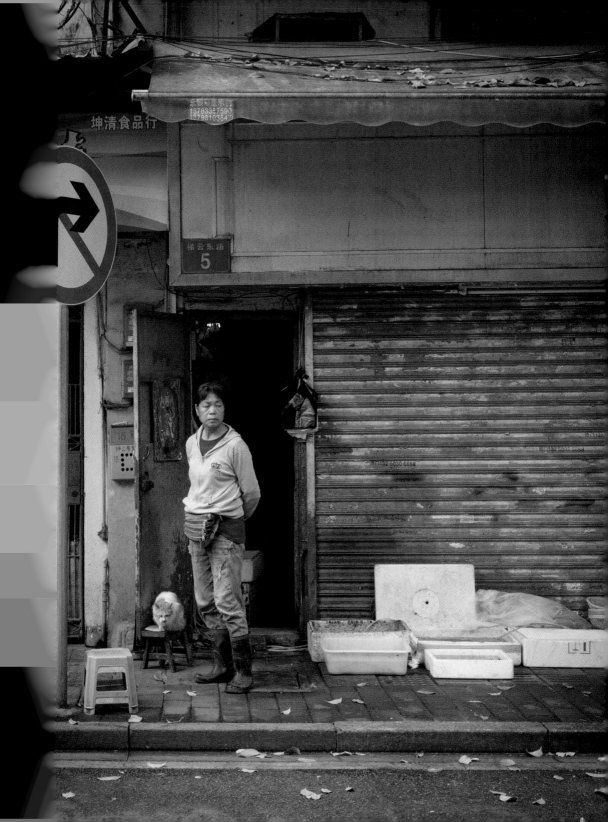

XU XU

We're closed. Tomorrow
you come; we wash, cut, layer
A new version of you

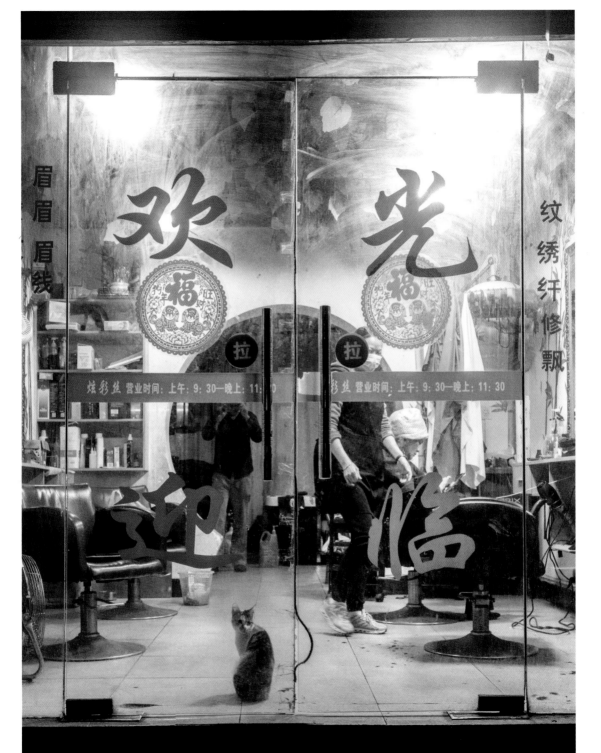

They may sleep all day

but when they walk, they have purpose;

looking for options

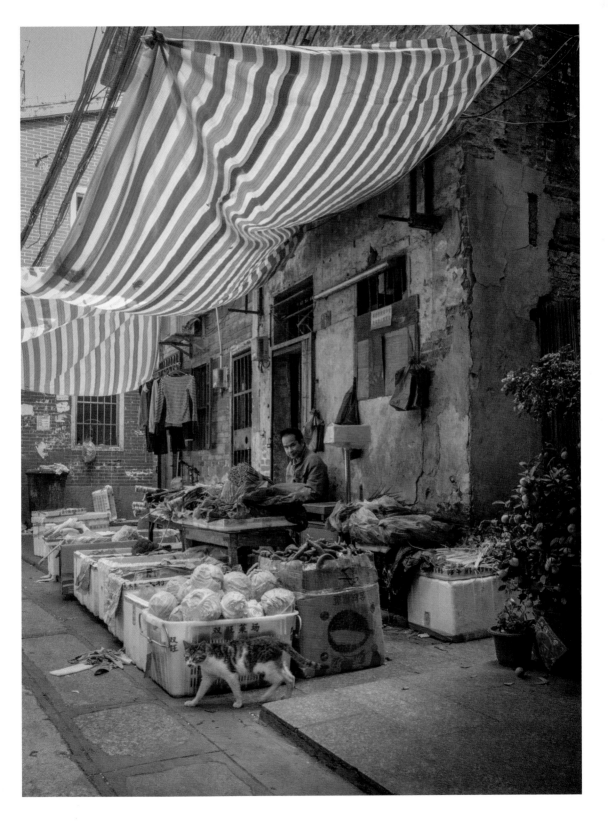

The prayer wheel spins
The abbot asks for blessings and peace
A cat prays for food

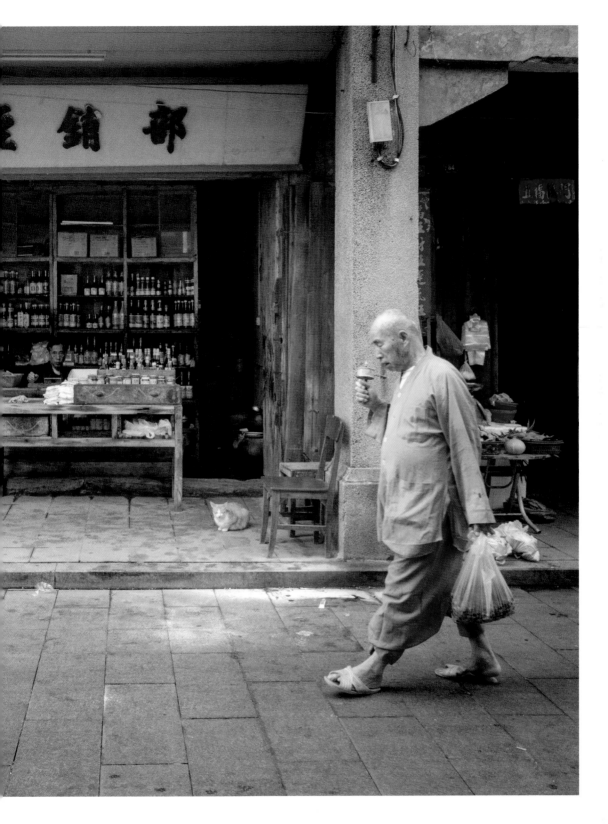

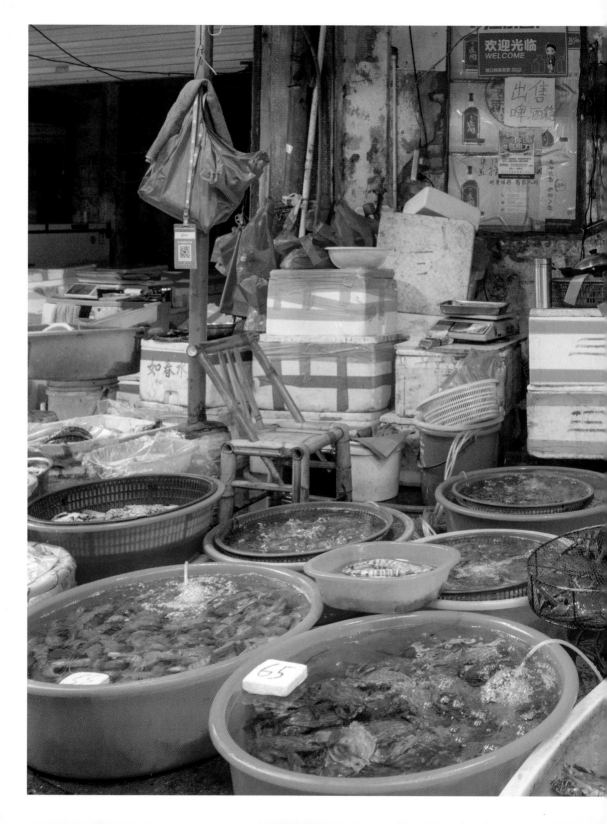

The funny thing is –
Promise me you won't laugh! –
I don't like seafood

Beauty and power

come and go. When you drink the water,

remember the spring

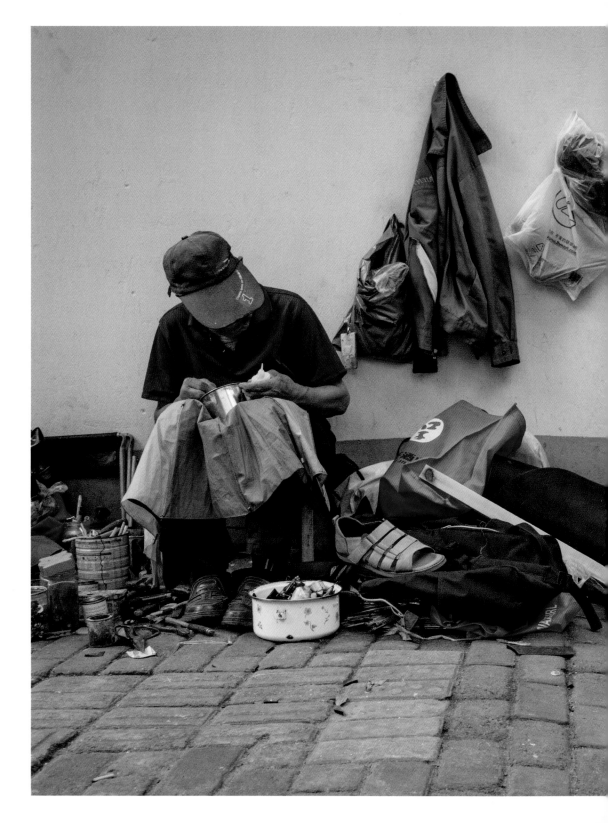

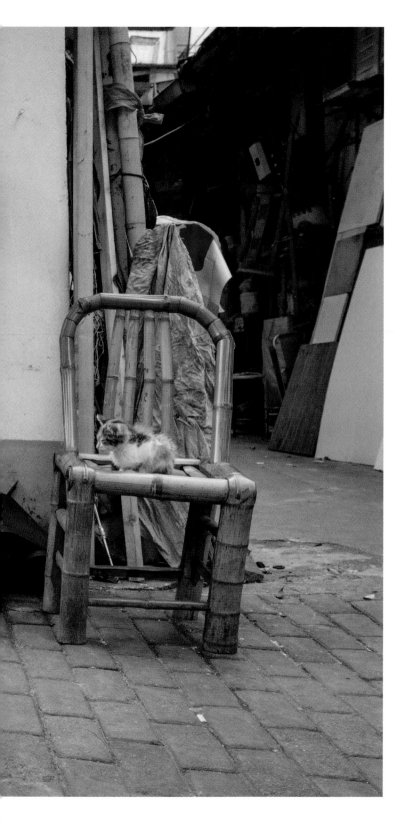

One day I'll learn how
to stitch and sew and patch and fill
the hole in my heart

Playing hide and seek
Old man grows weary but she
just wants to be found

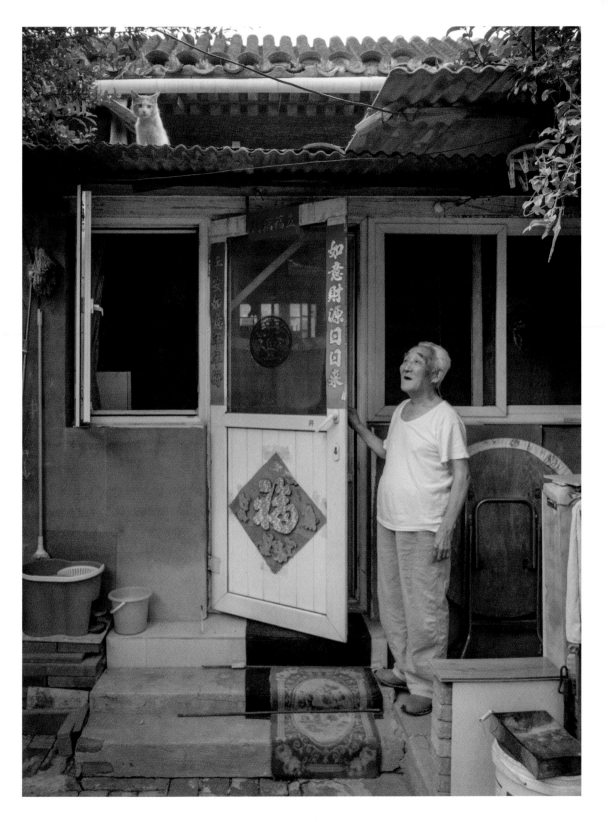

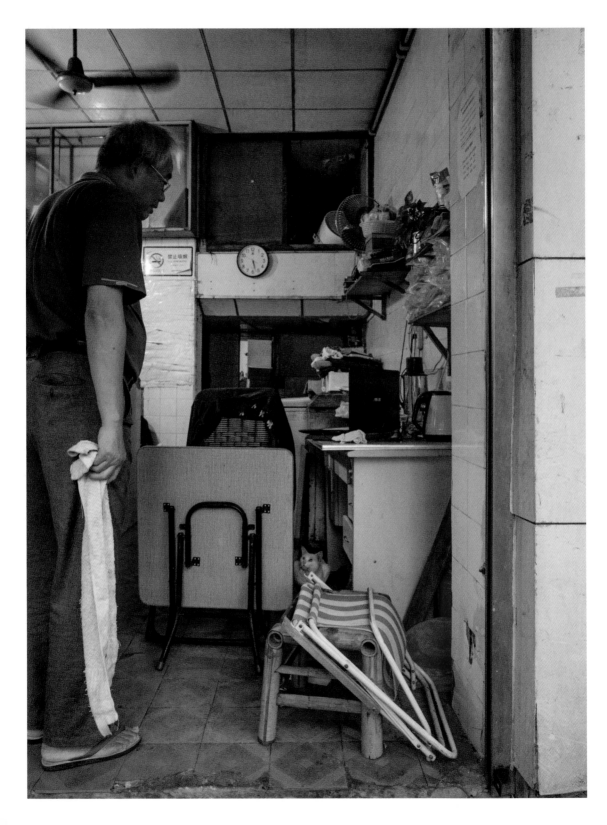

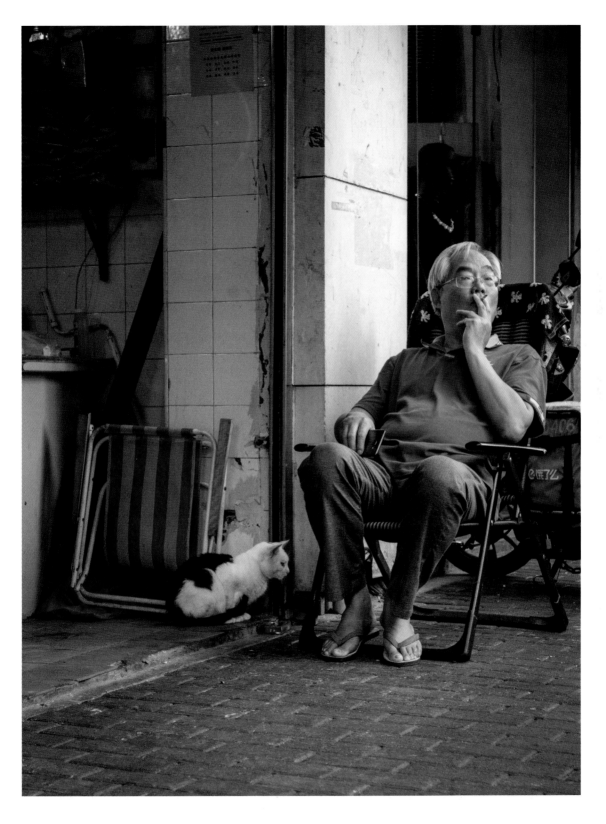

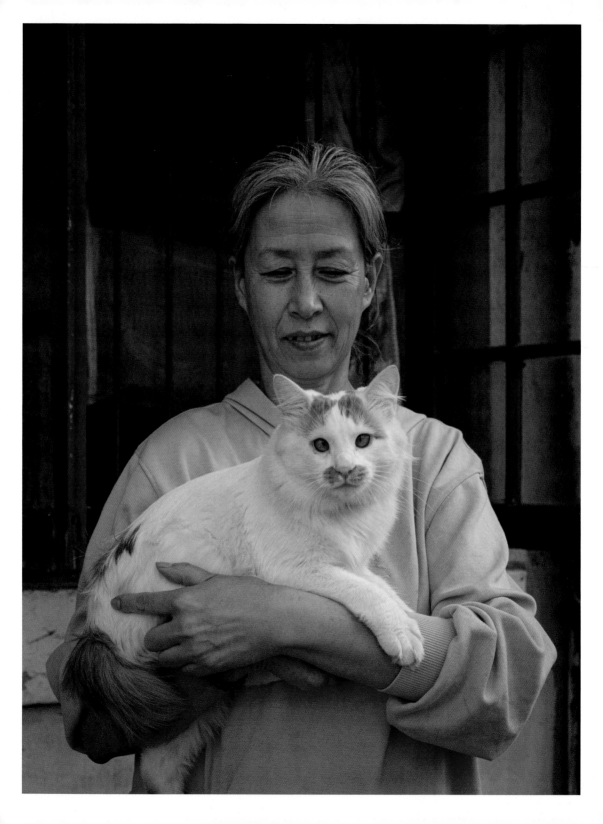

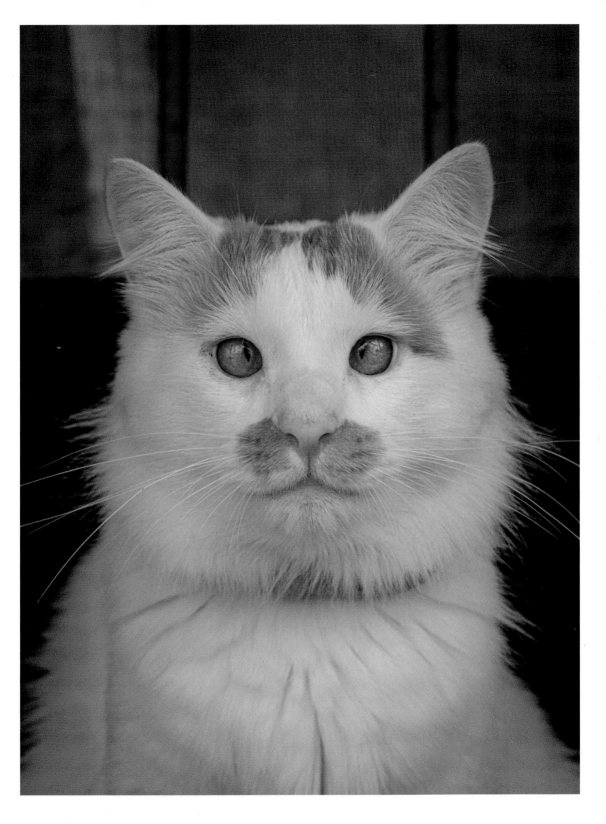

Don't wake him up,
he's tired. He's entitled to
a little cat nap

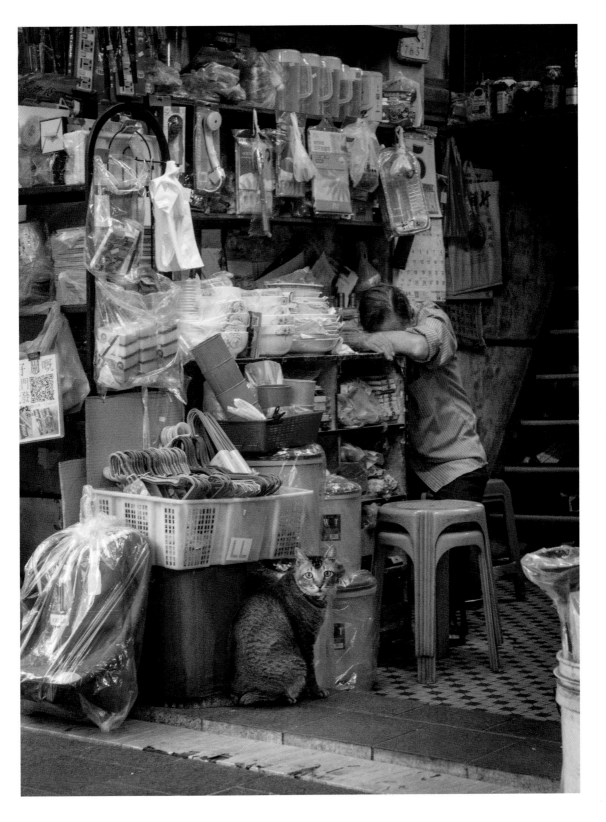

I'm back

I changed my mind

I'm sorry

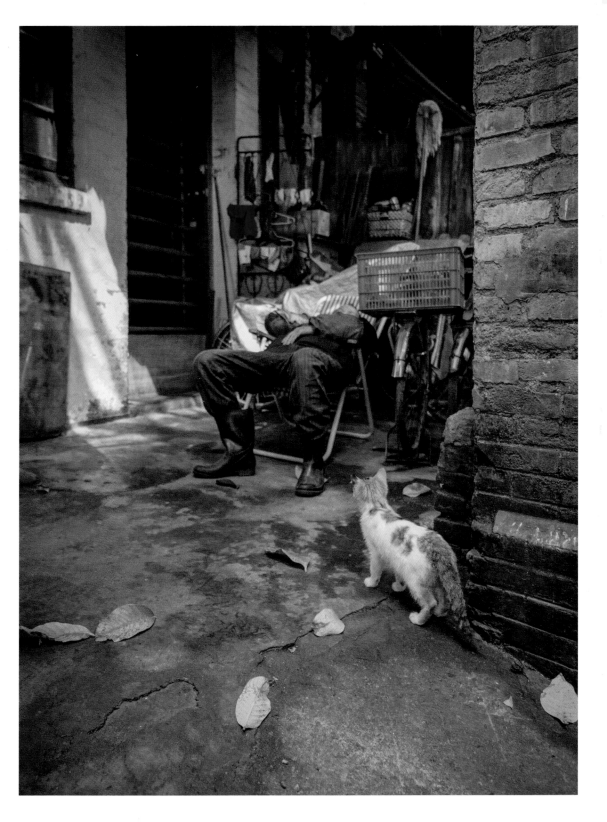

At some point, the end
is closer than the beginning
Our days are numbered

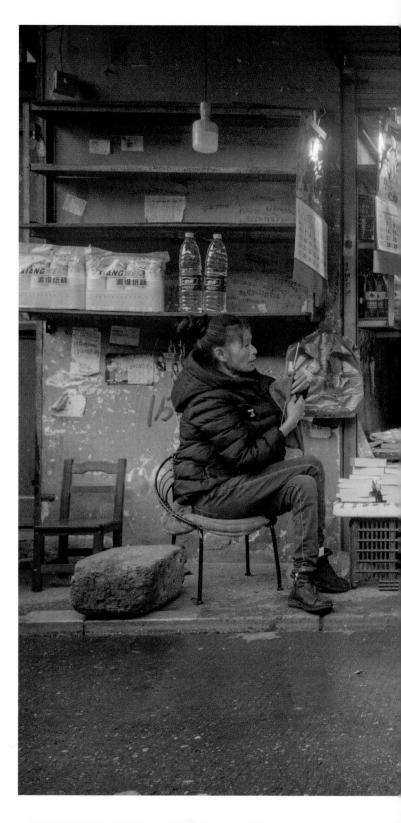

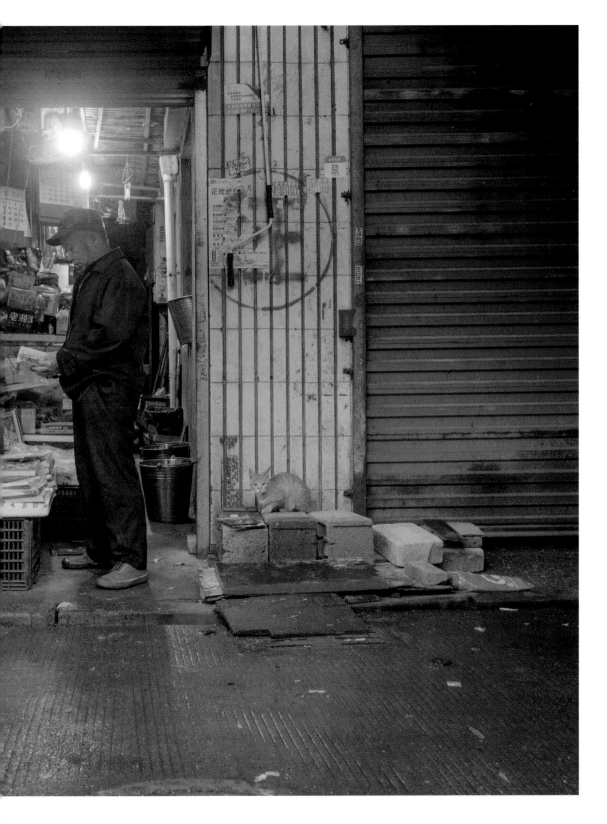

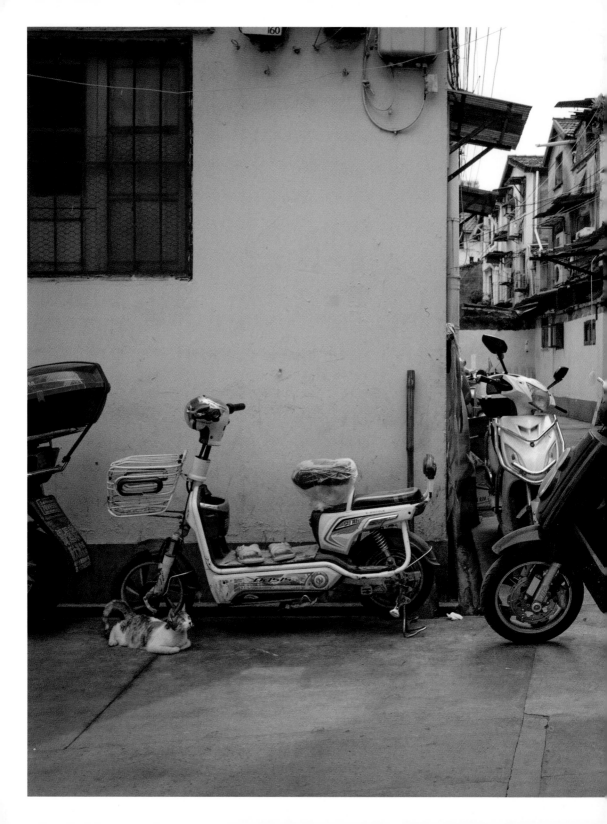

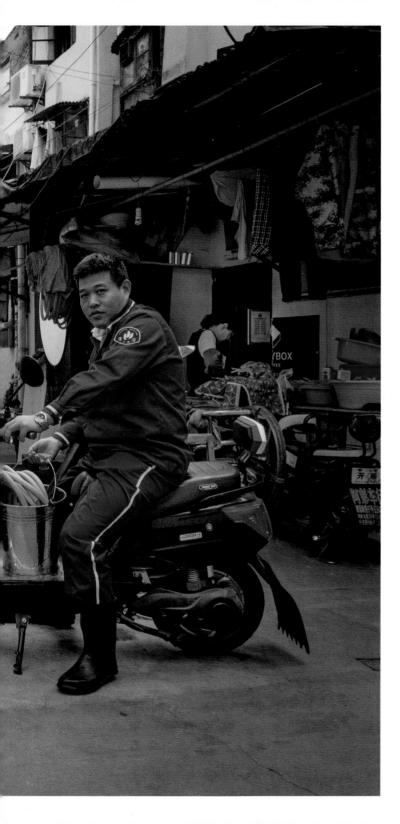

When I grow up

that's who I want to be

A human cat

When she falls asleep

that's my cue: time to start my shift

I work to live

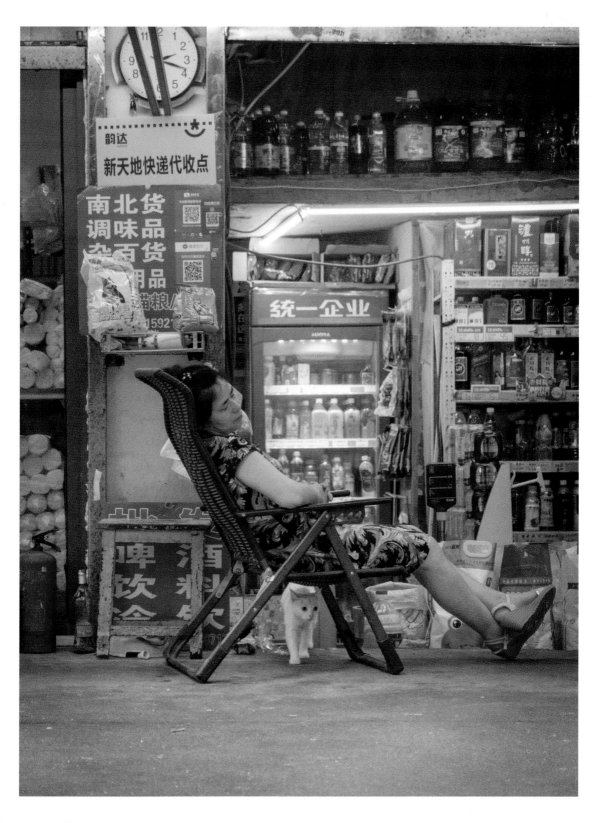

Haven't you heard of
a security cat? Can't talk,
I'm working

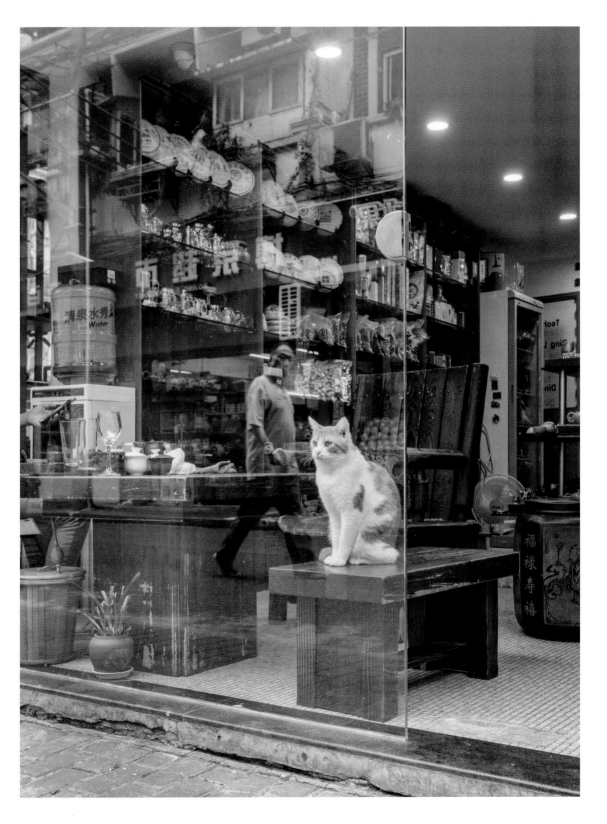

DA TOU
(BIG HEAD)

The Guest Relations Officer

As Guest Relations Officer, Da Tou is the first face you see when you enter the shop. He's also the first voice you hear as he beckons you to take a seat and signals to his master's son to bring you a glass of jasmine tea. His first task is to make you feel welcome – once you're comfortable, he'll take your order and commend each selection.

As Da Tou packs the dried mushrooms and the different types of bark and nuts, he will suggest you try something new. It won't be something you've considered before, so you are unsure. That's when he looks you straight in the eyes, reads you like a book, and persuades you that it is what you need to cure the crick in your knee, remove the worry from your brow and fix that problem in your heart.

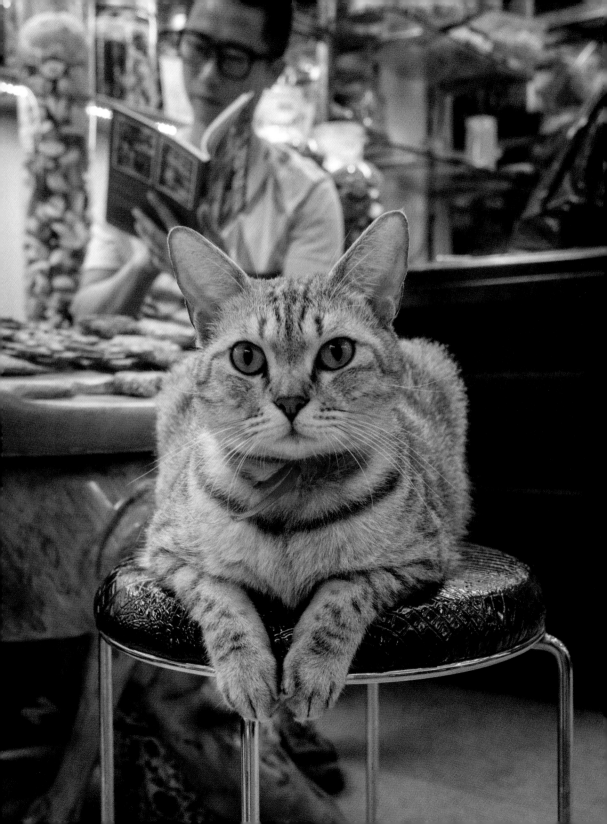

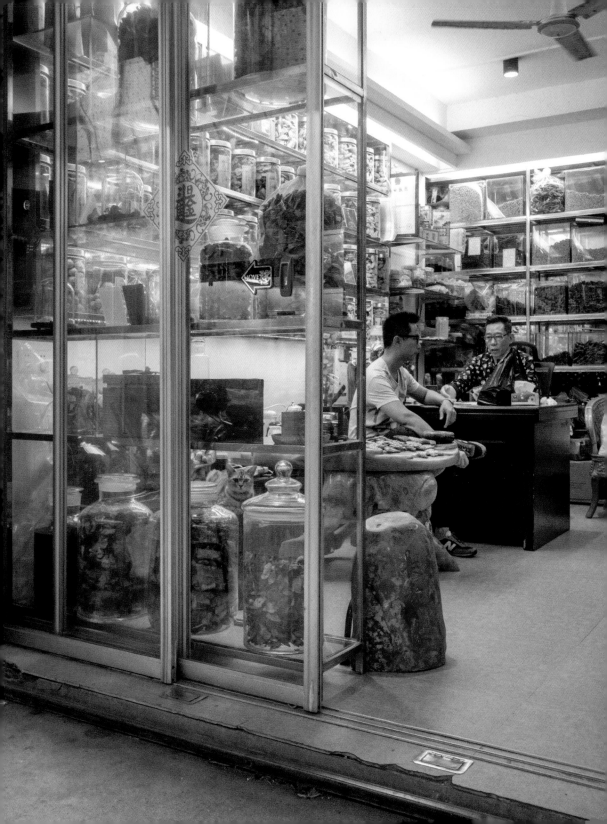

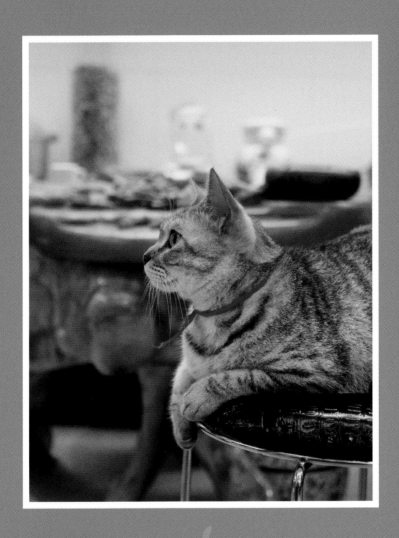

大

DA TOU

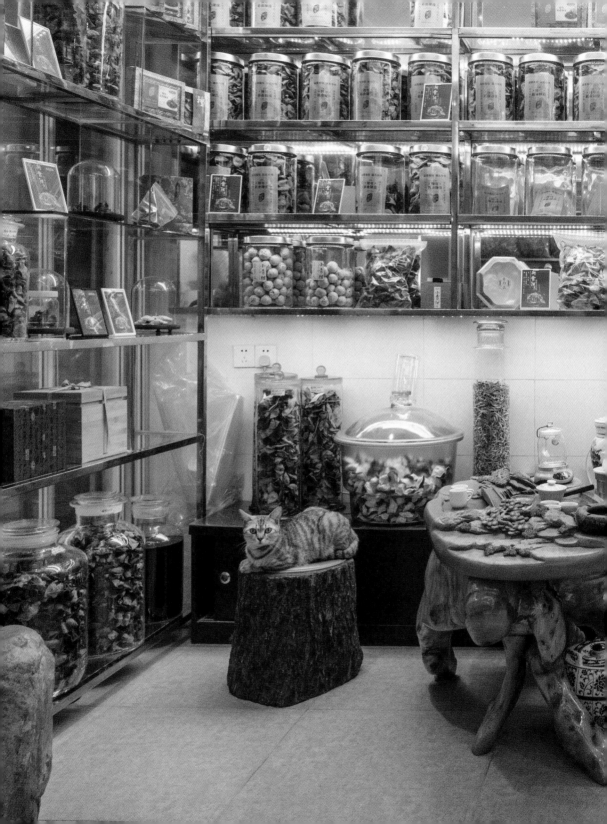

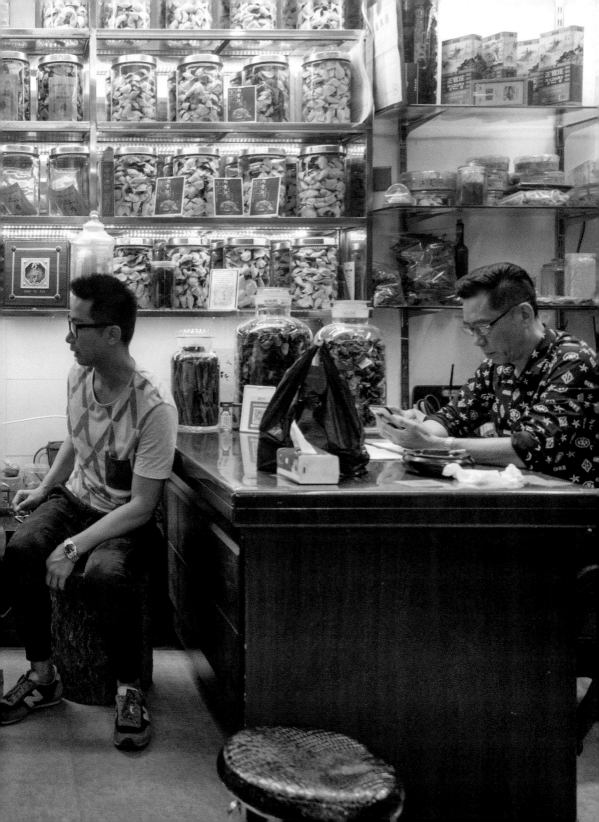

I'm in heaven

Heaven is place on earth

I'm falling up

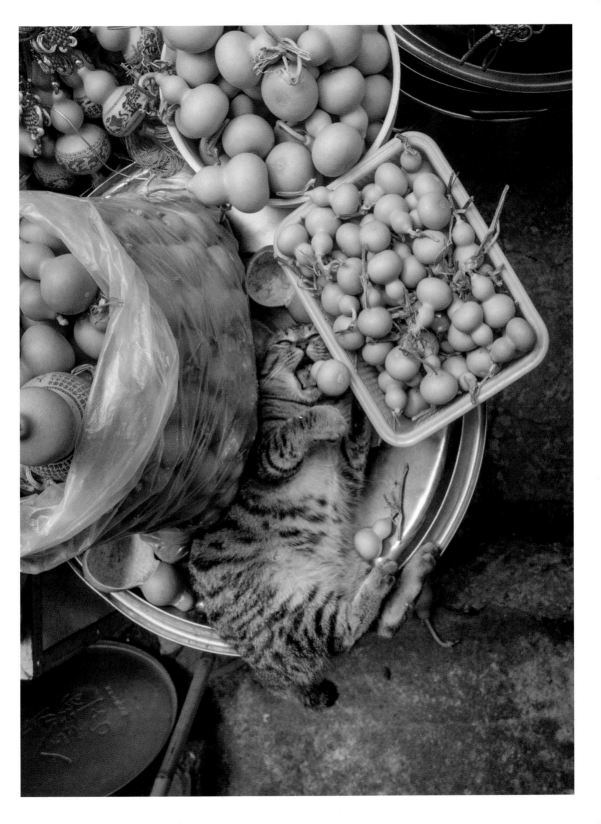

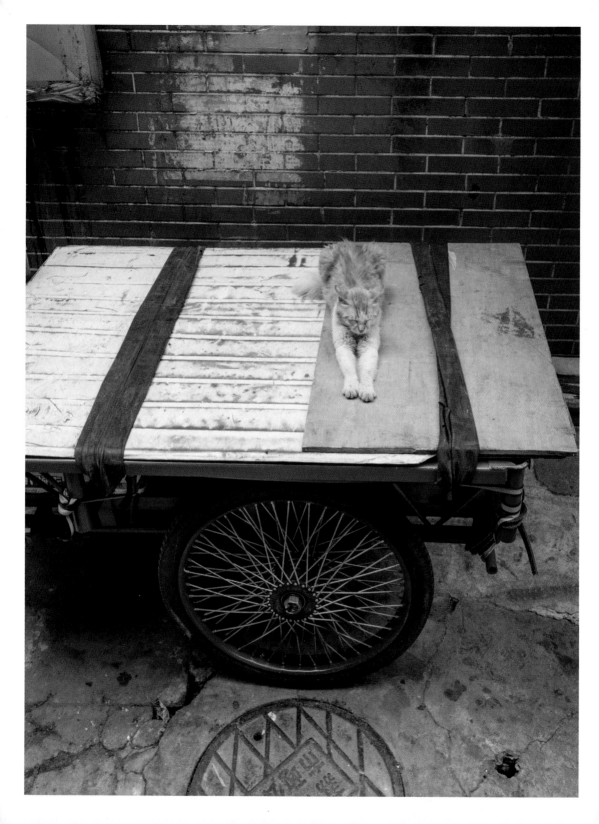

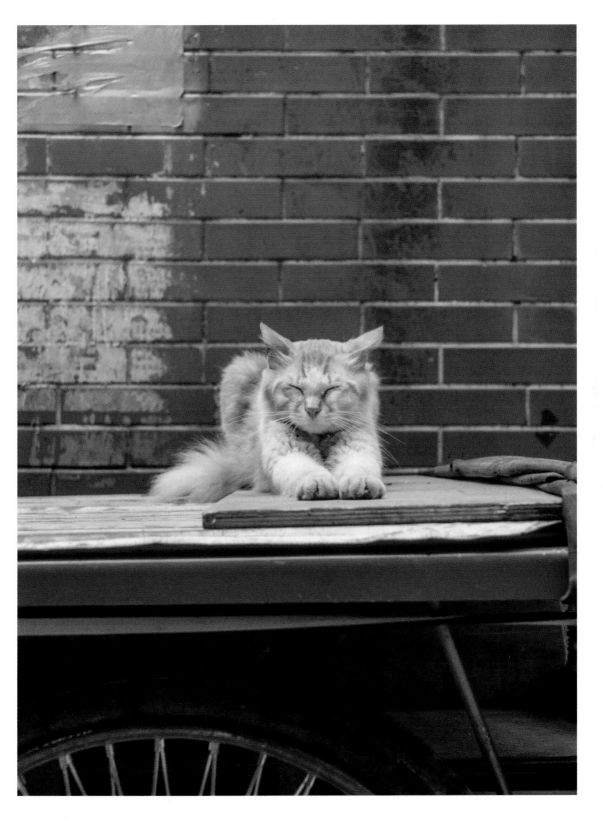

I'm leaving

There is nothing here for me

There is nothing

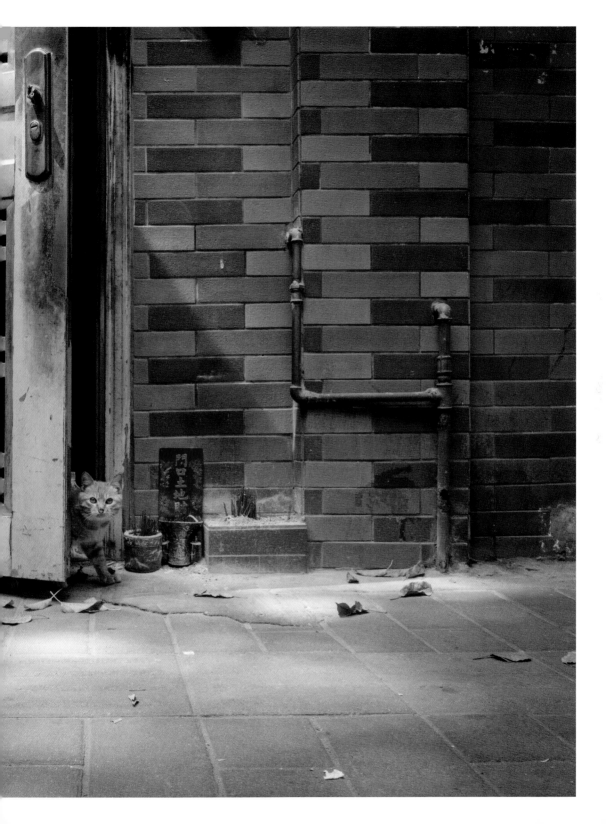

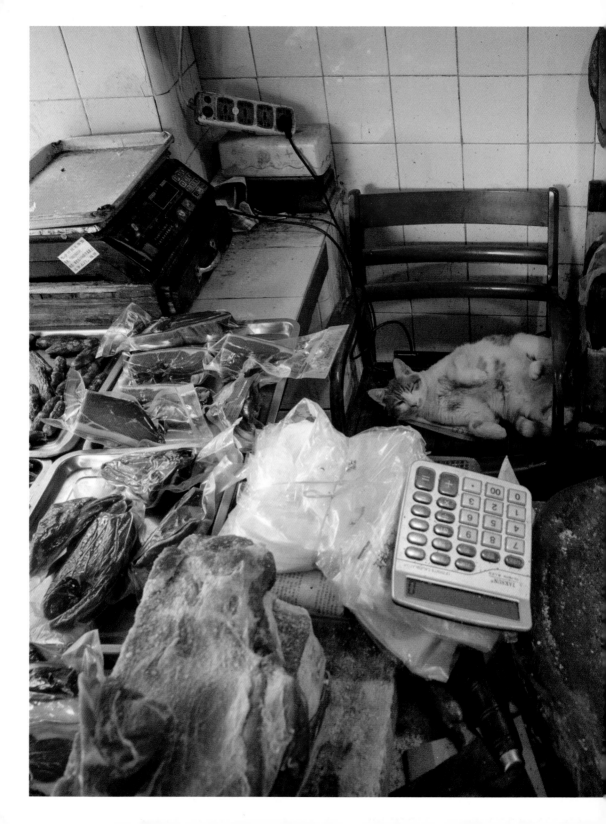

The headline reads –
Local cat wins the rat race,
takes a nap

Everything he knows,

said the cat, he's learned from me

Live in the moment

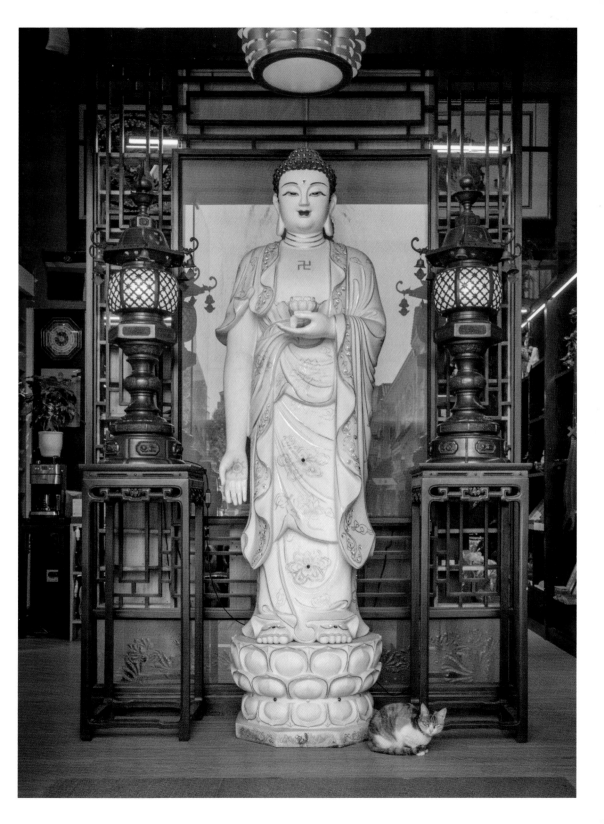

I don't get the joke

He's not funny but his belly ...

soft like a pillow

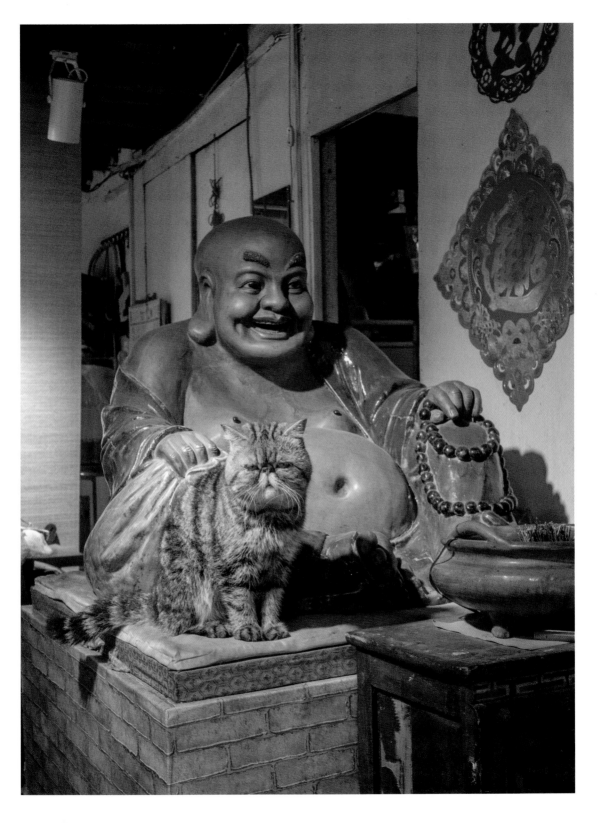

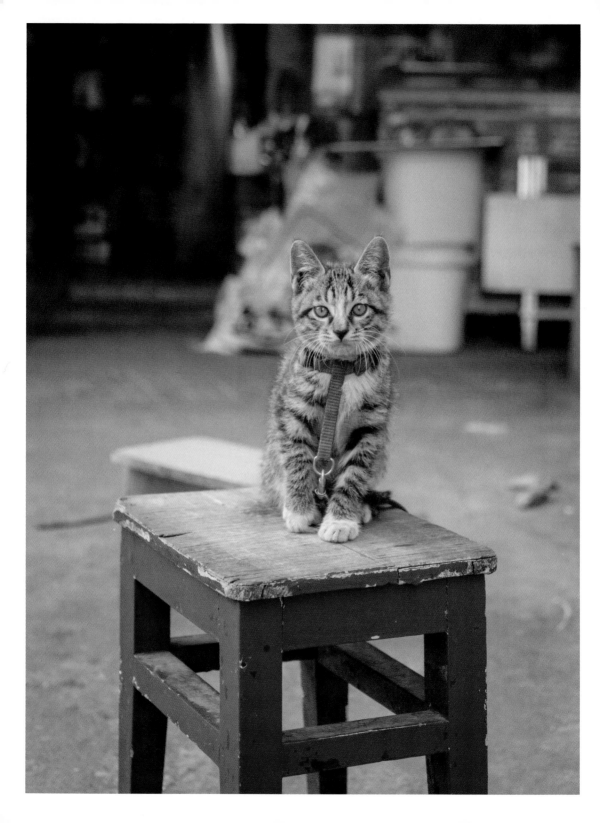

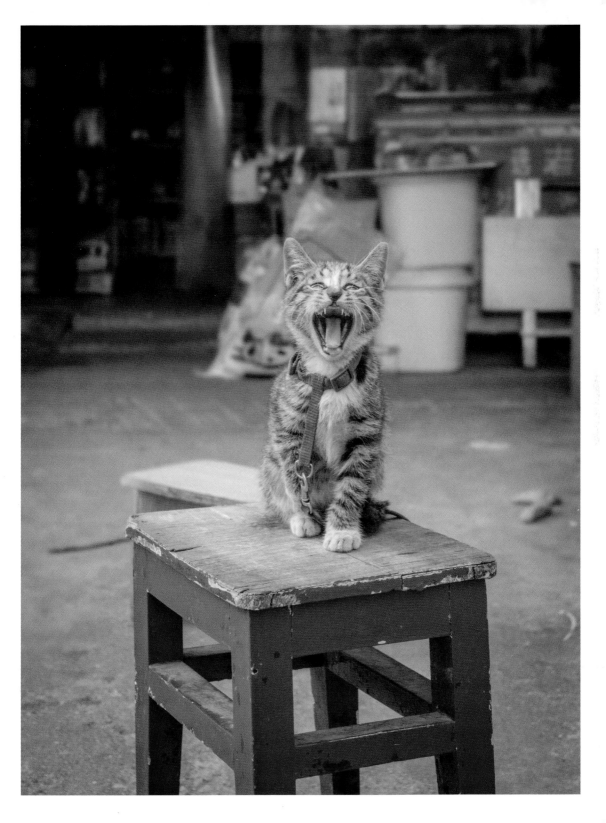

Did I say you could
take my pic? At least let me
put something on!

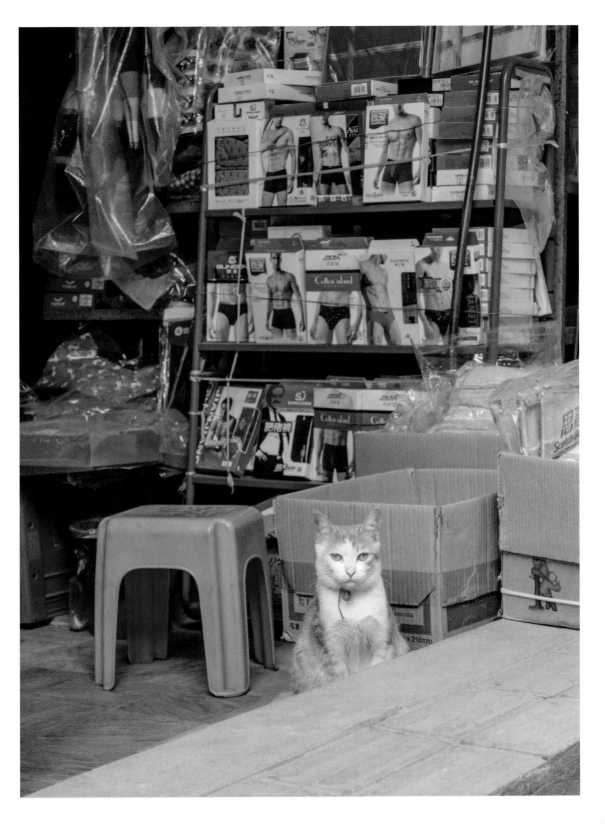

You're here again
Where do you take them and why
don't they come back?

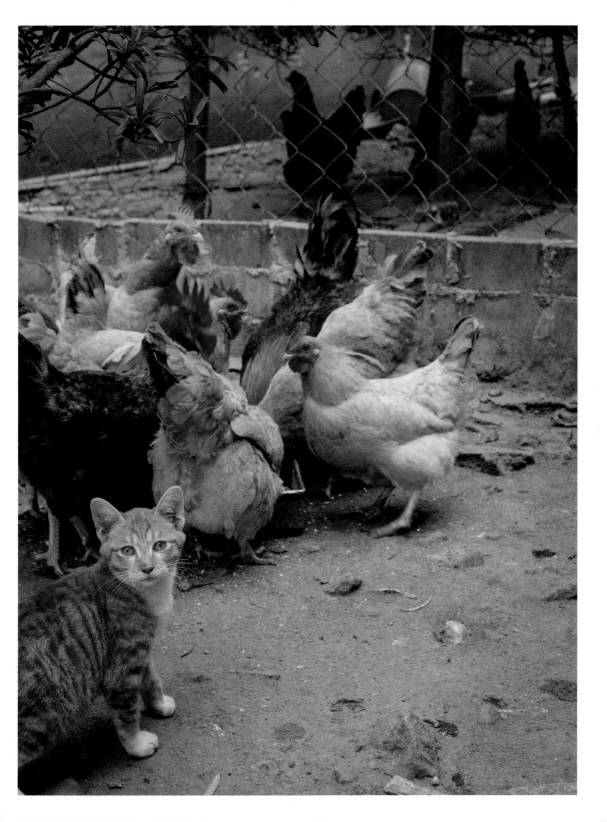

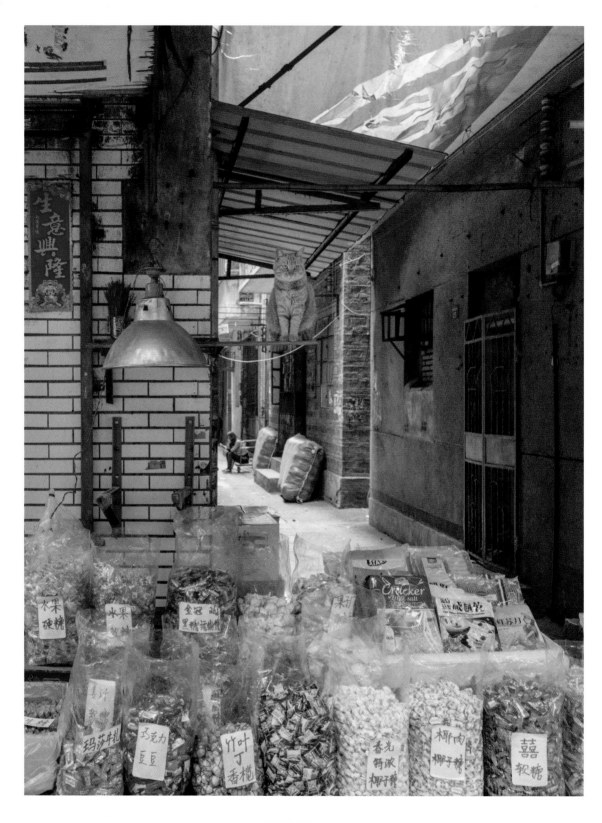

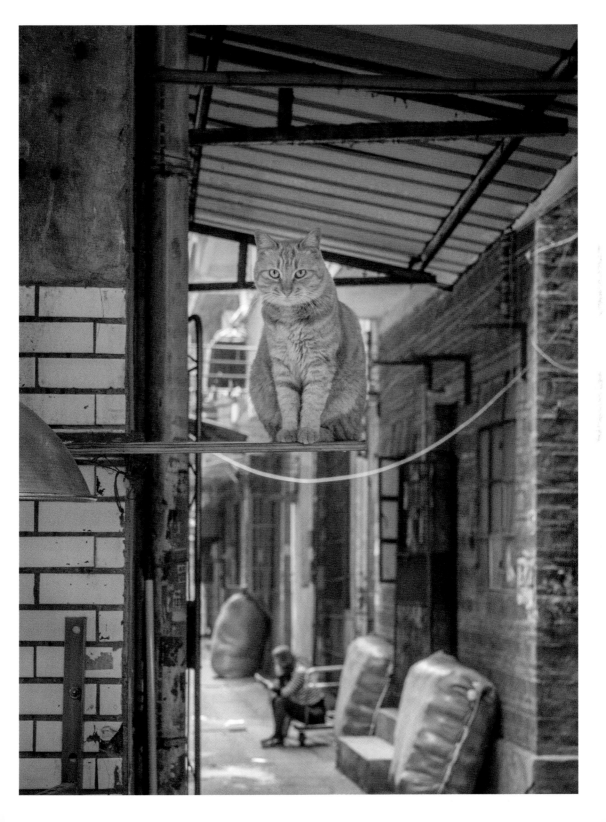

Maybe I've seen her

Maybe I have information

Maybe I'll tell you

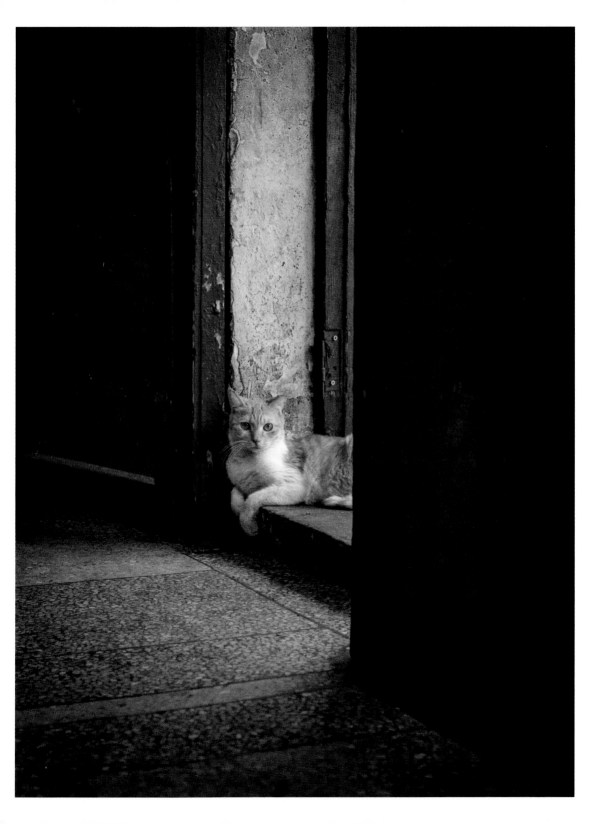

Distraction – in her
mind, a precise assessment:
should I stay or flee?

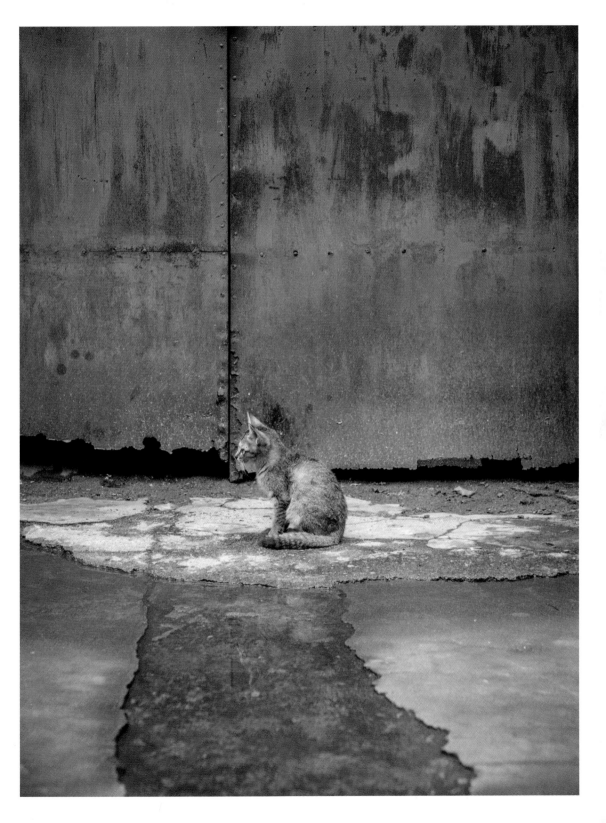

XIAO BAI

(LITTLE WHITE)

The CEO

I was very young when I started out. I was two when my owner's granddaughter gave me to her to keep her company. Grandmother had other ideas. A cat needs skills if he wants to survive in this world, she said. Who's going to run the place when I'm gone? So she taught me how to run a shop, negotiate with suppliers, serve the customers. And then on my sixth birthday, I became the youngest cat CEO in this entire district. Does my make-up need a touch up?

Grandmother continues to work in the shop, but it's up to me to grow the business. I'm now trialling the home-delivery service, as humans are becoming lazy and want their groceries delivered to their doorstep. Do you know how hard it is to find cats with motorcycle licenses who are trustworthy and dependable? Just a few more pictures then I have to go! Lately I've noticed she can't carry heavy things and struggles to use the ladder. Even her eyesight is going, so I can't have her work the cash register, can I? I will have to have that difficult conversation. I'm not complaining. It's my job. Are we done?

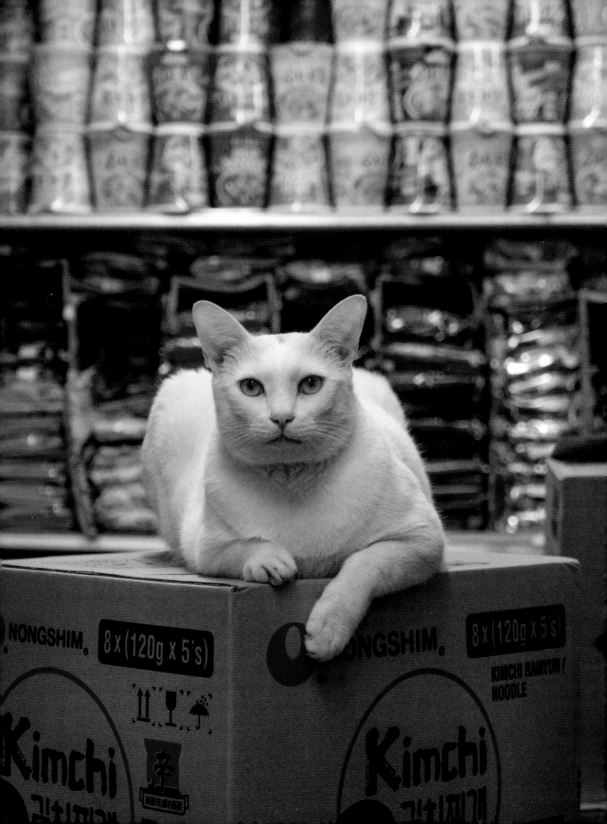

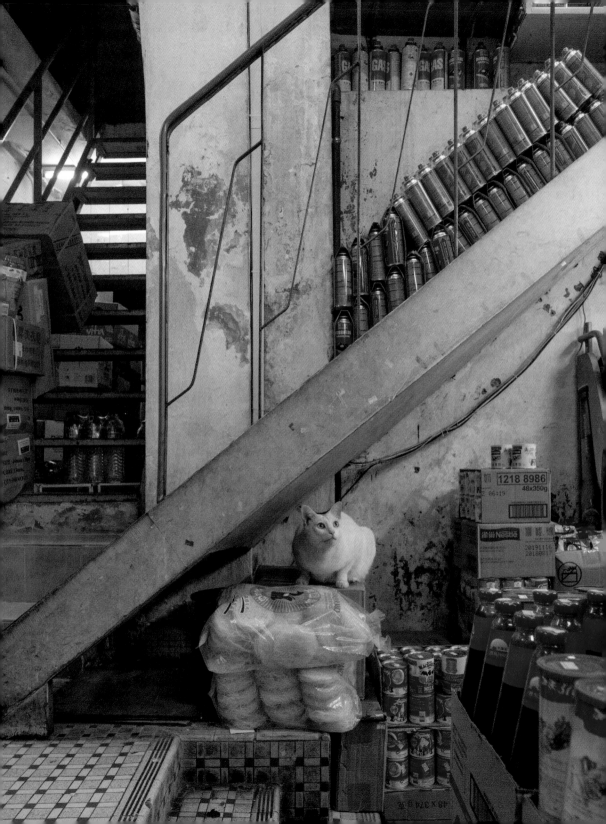

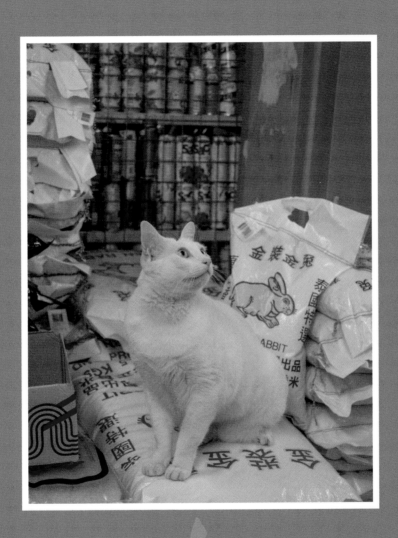

XIAO BAI

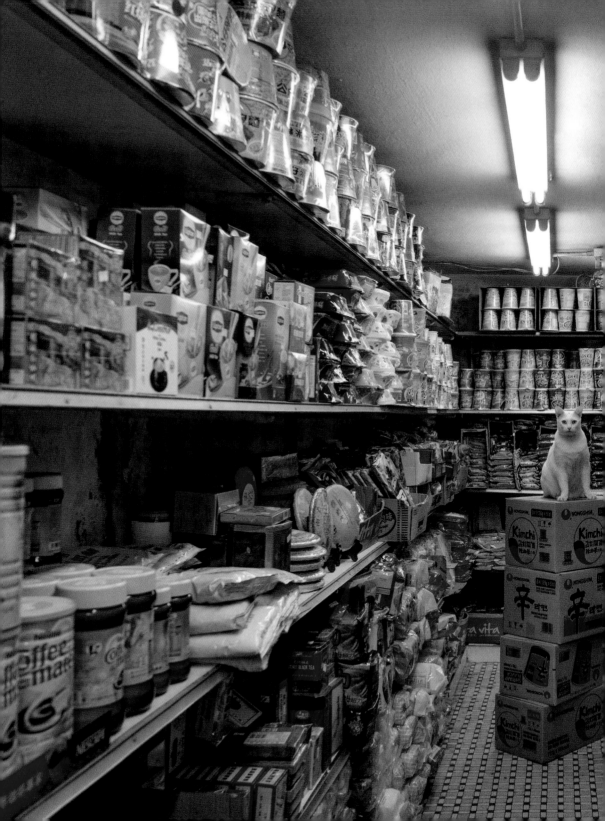

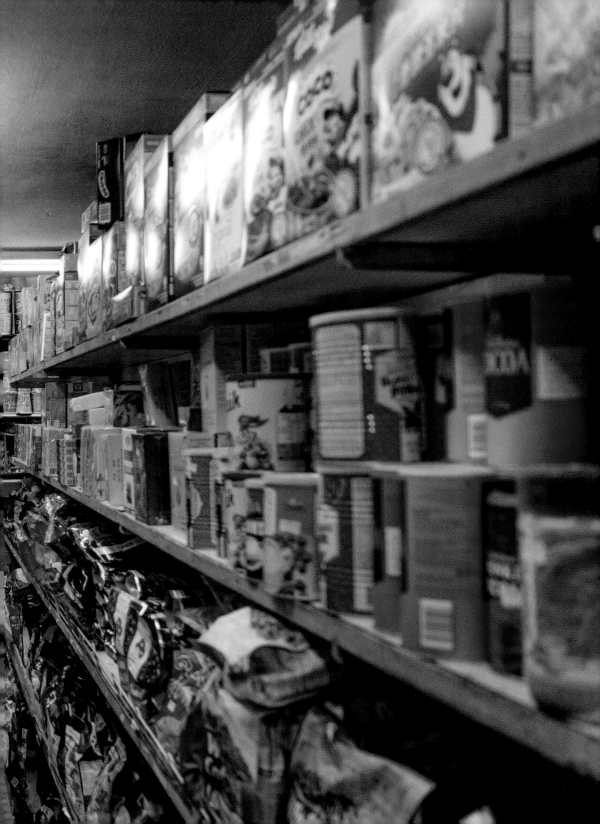

I wear my heart on
my face, heavy with confusion
my frown is my crown

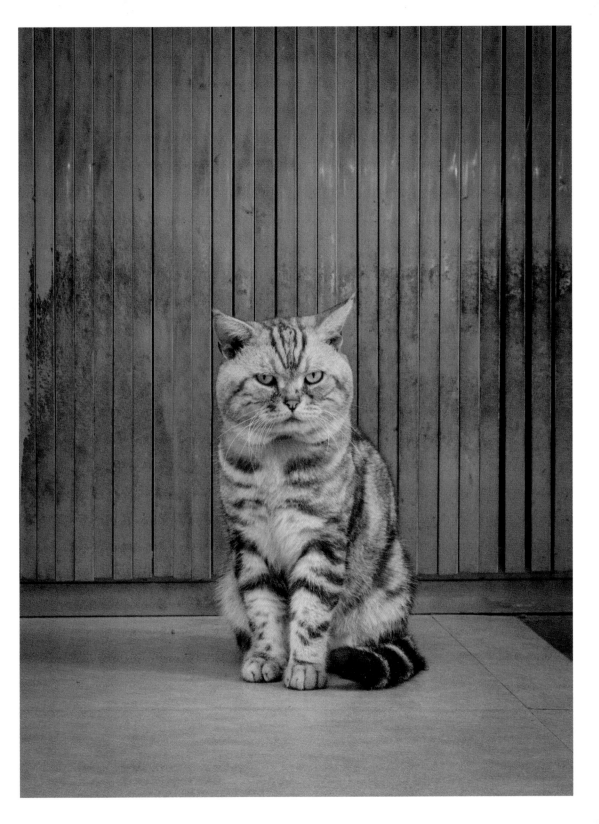

The human is a
savage beast. What did she
do to deserve this?

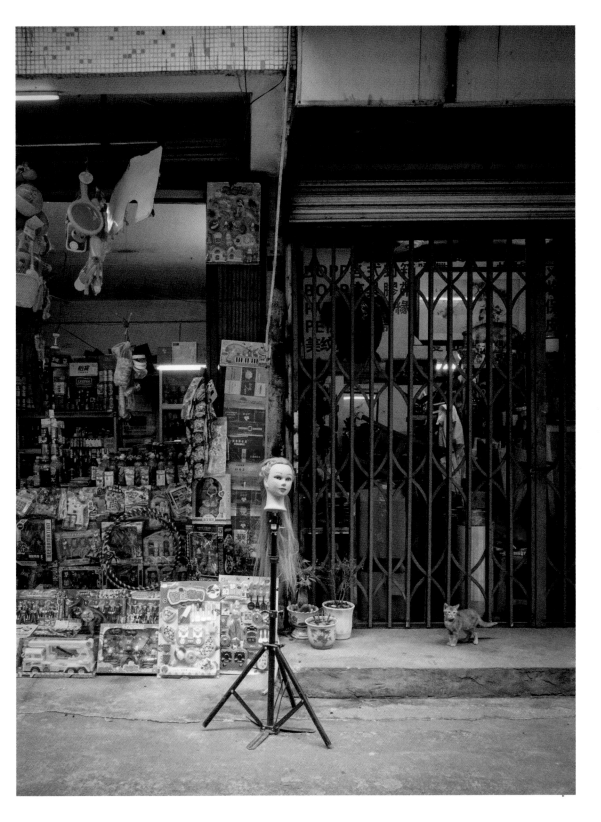

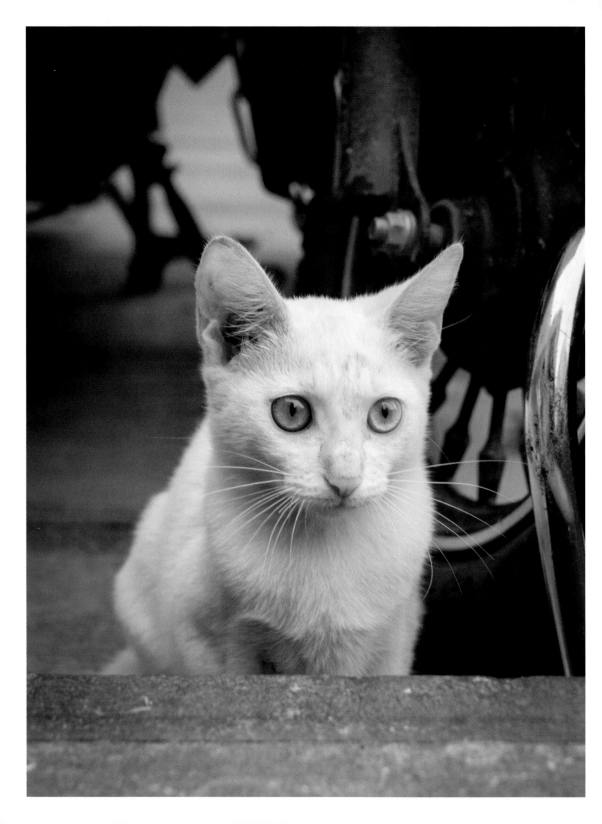

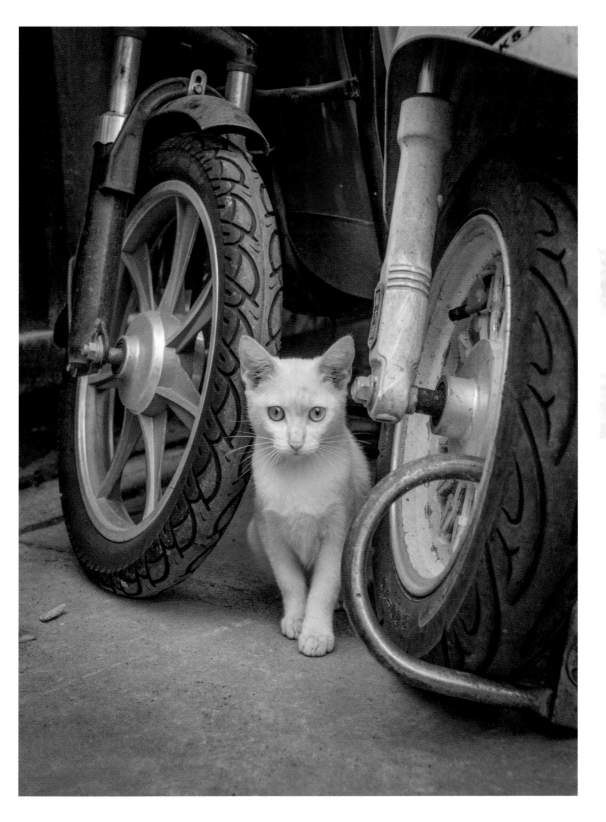

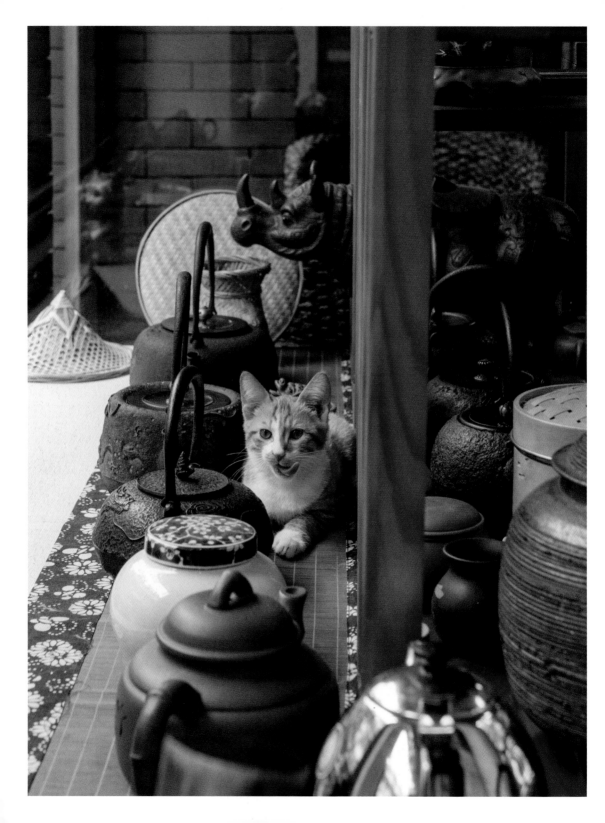

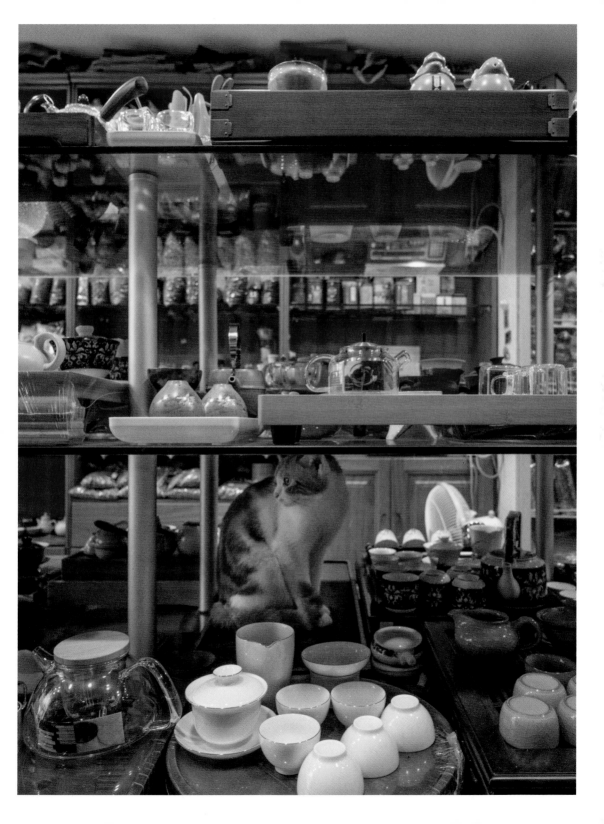

I'm in trouble –

I like chicks, they're my friends;

you don't eat your friends

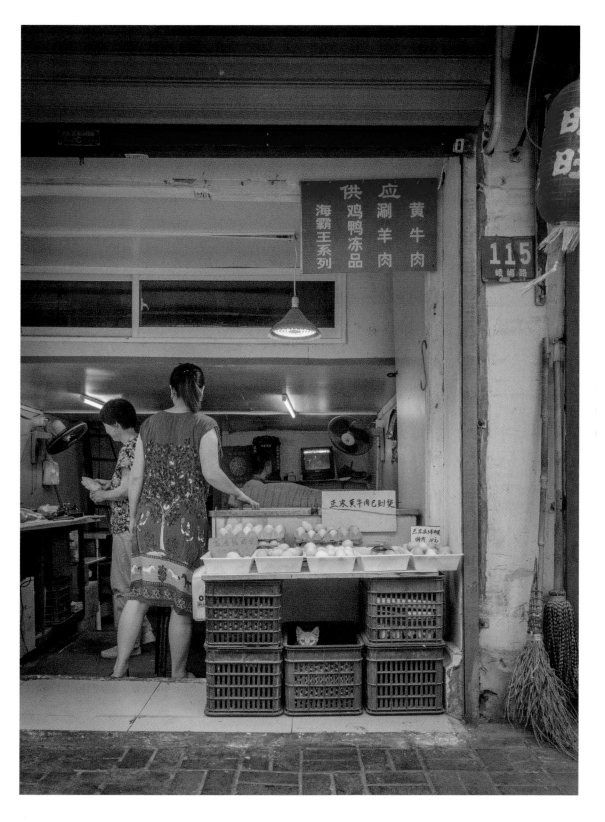

Get the message:

I am not eating that rubbish

How 'bout some chicken feet

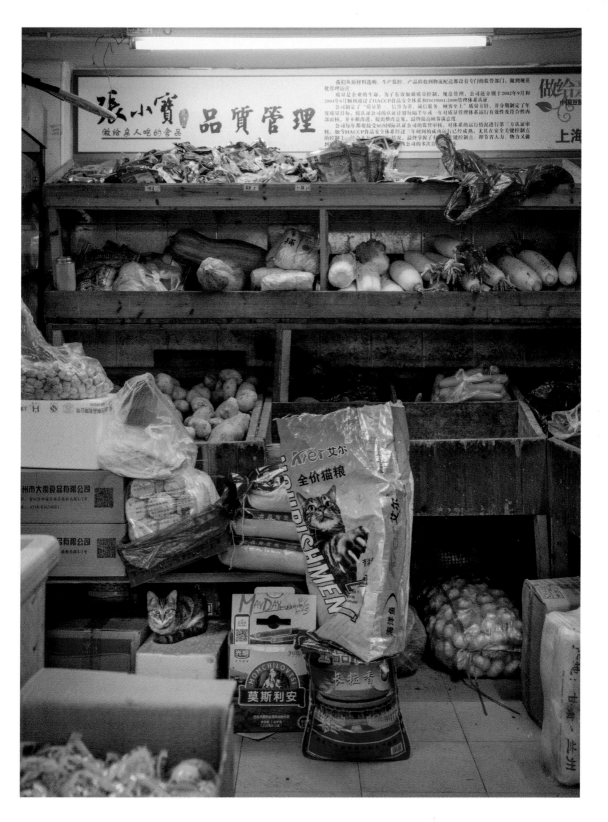

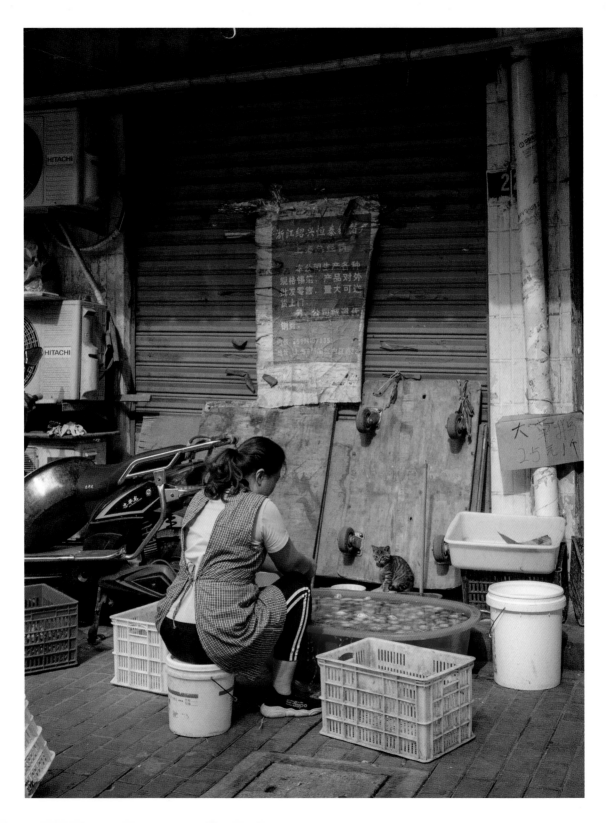

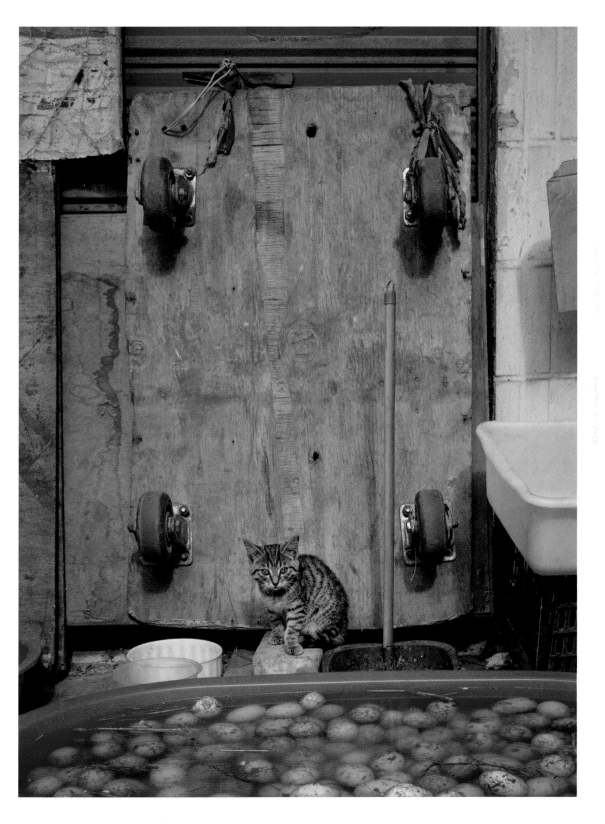

Little as you are ...

Your ancestors are behind

Watching over you

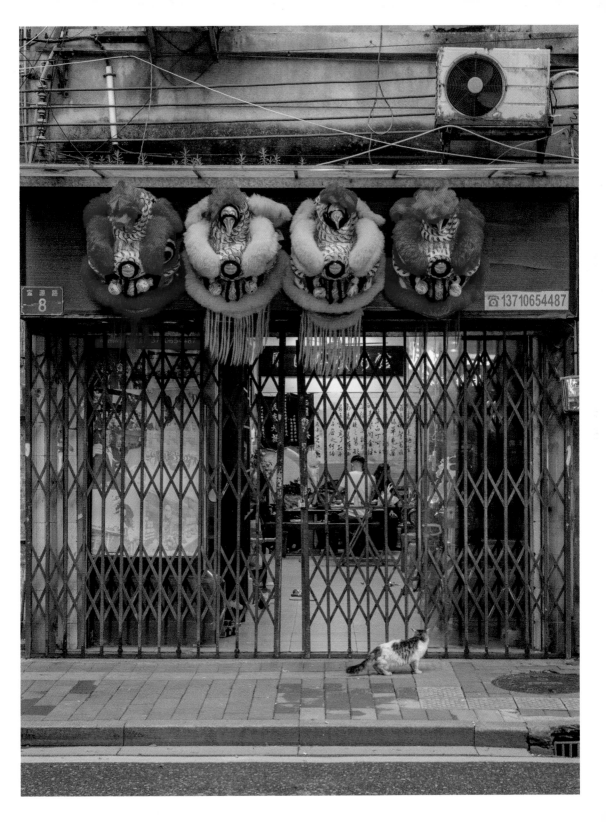

Don't feel sorry for me
I'd rather be locked in
than locked out

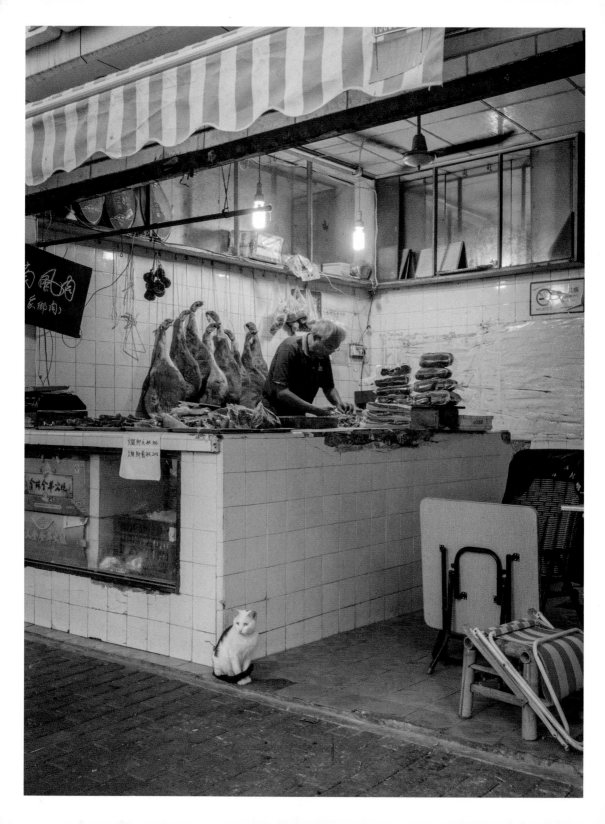

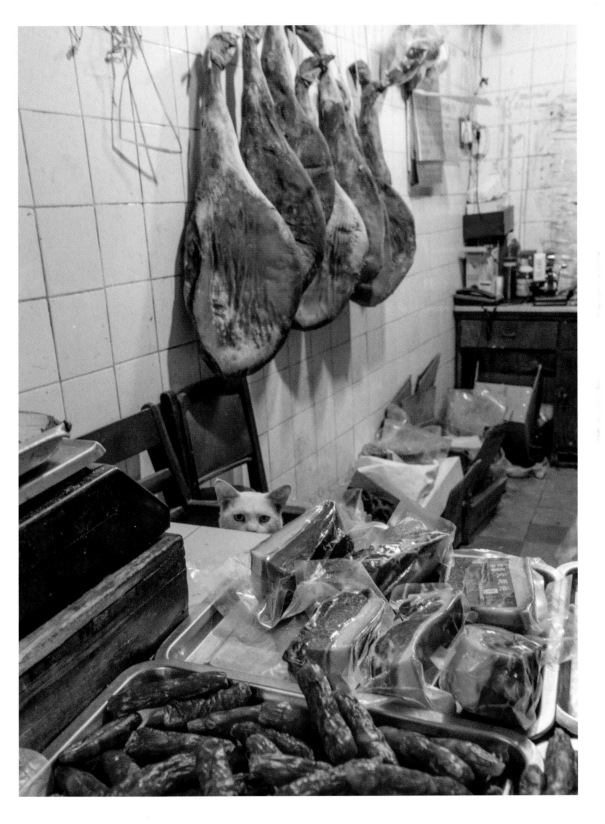

Little pussycat
scared of the big cock;
it's not funny!

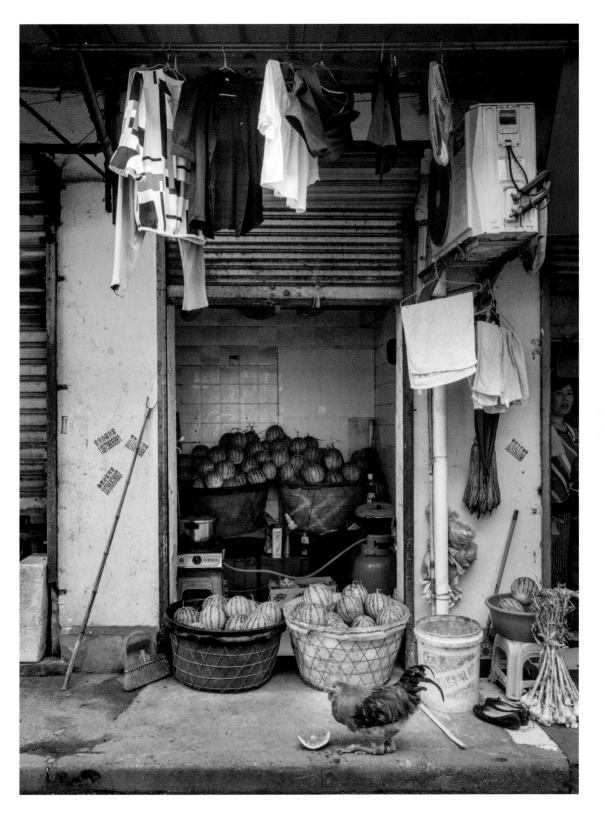

Not all sweetness and
cuddles; in my spare time I am
a death-defying cat

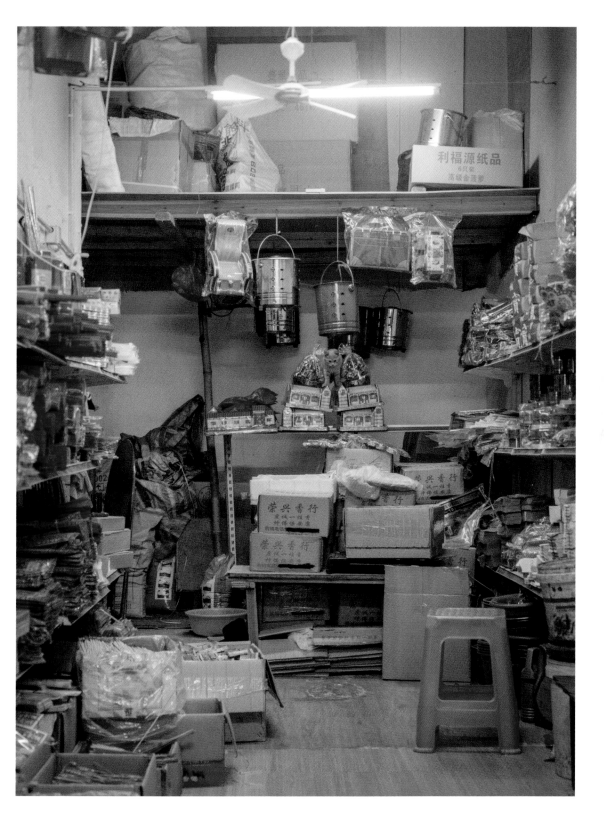

Some cats stay put

Those who need to roam or run

need a getaway car

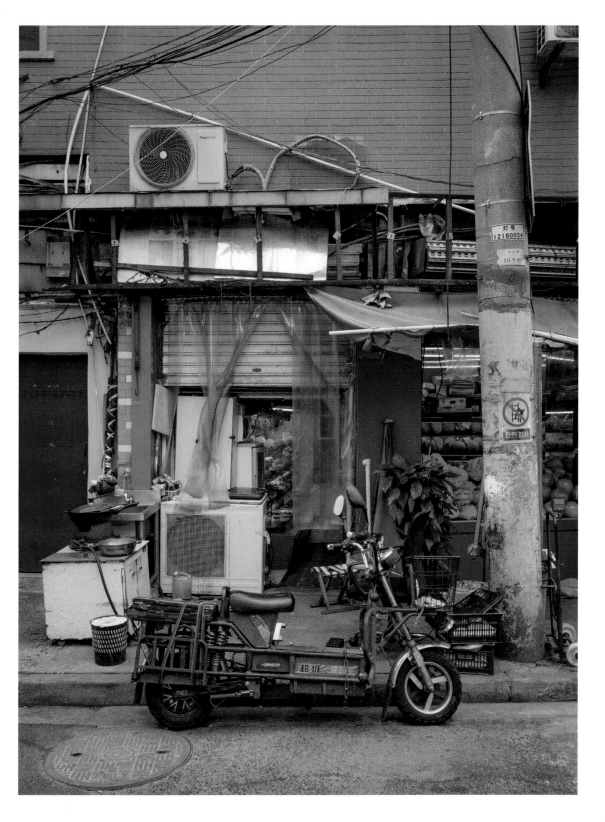

You won't believe this
This is where chickens come from
I've seen it happen

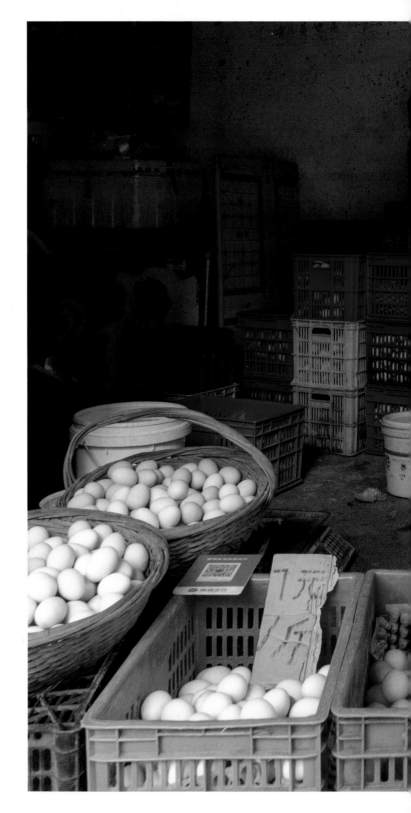

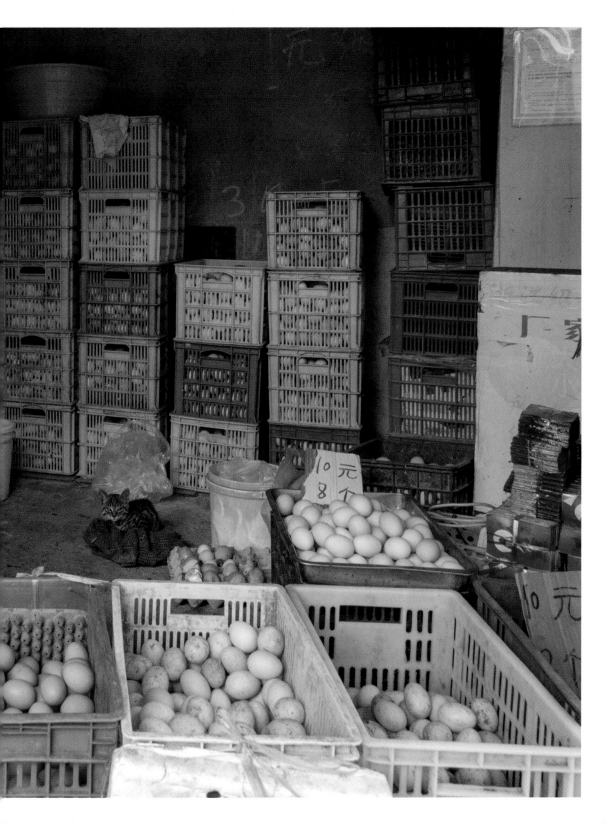

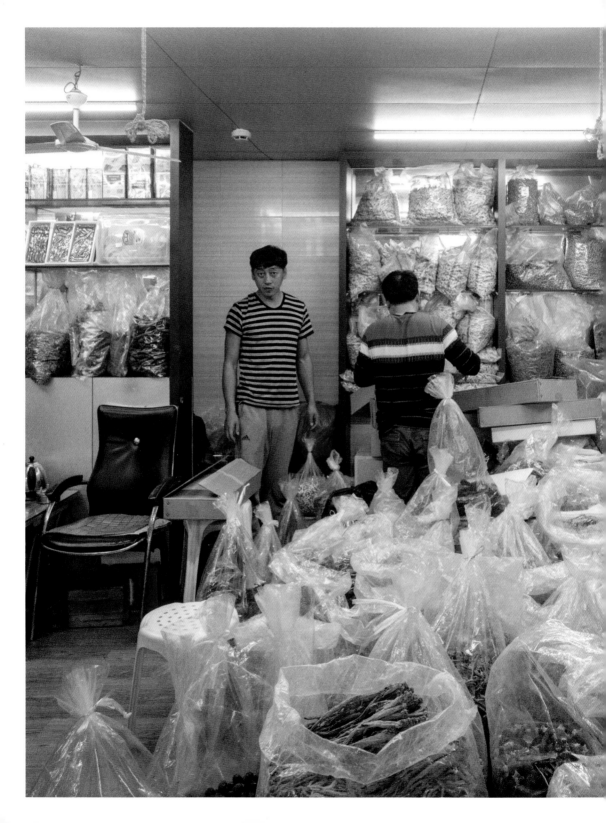

Can you find me?
If you see me, don't tell him!
I'm hiding!

I need a lift

I'll make you a deal, if you drive

I'll navigate

Hide and seek
Waiting, wanting to be found
to be loved

Silently she moves

away; seeks cover but that tail means

she wants to be found

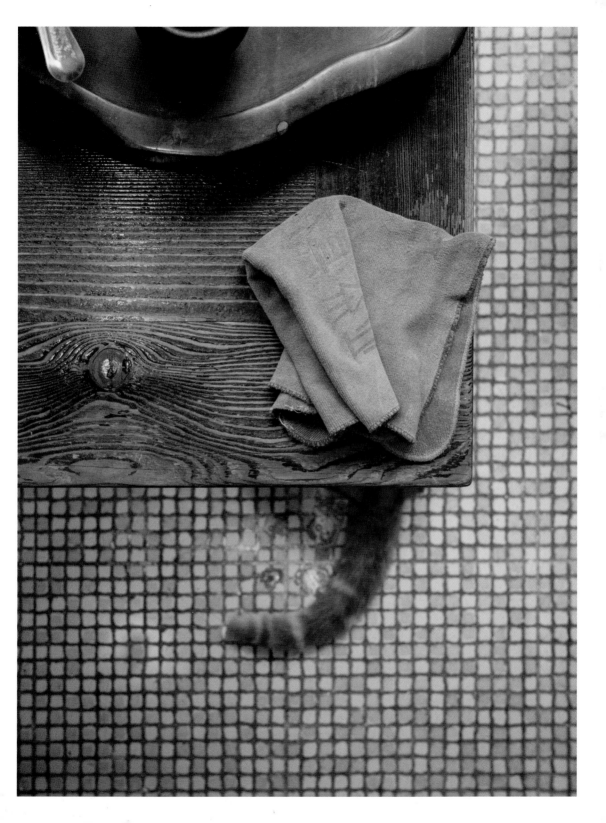

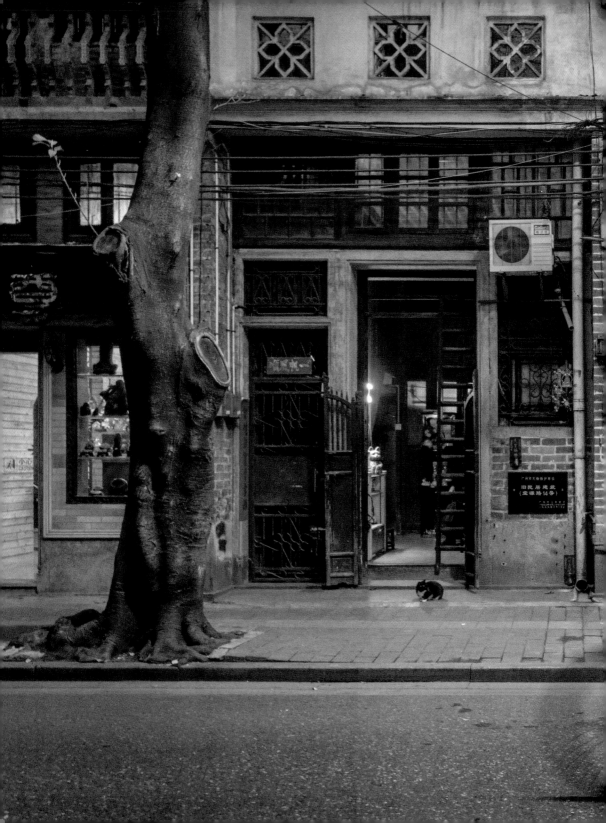

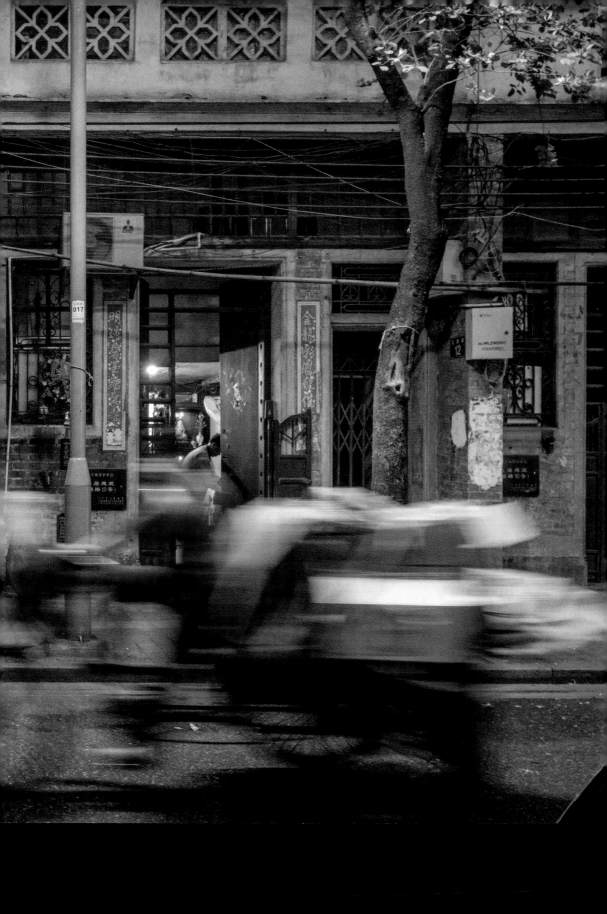

Ian Row was born and raised in Singapore and now lives in Melbourne, Australia. Row has written haiku since 2006, when he realized how useful the form was in helping him to exist in the present moment. He now writes a blog called Hot Cross Haiku.

First published in the United Kingdom in 2021 by
Thames & Hudson Ltd, 181A High Holborn, London WC1V 7QX

First published in the United States of America in 2021 by
Thames &Hudson Inc., 500 Fifth Avenue, New York, New York 10110

Shop Cats of China © 2021 Marcel Heijnen
Photography and design © 2021 Marcel Heijnen
www.chinesewhiskers.com
Instagram: @chinesewhiskers

Haiku and cat stories by Ian Row, www.hotcrosshaiku.com
Foreword by Catharine Nicol
Calligraphy by Mark Chan 墨山, www.markchan.com
Author photograph by Aleksander Solum

British Library Cataloguing-in-Publication Data
A catalogue record for this book is available from the British Library

Library of Congress Control Number 2021934157

ISBN 978-0-500-29611-0

Printed and bound in China by 1010 Printing International Ltd

FSC
www.fsc.org
MIX
Paper from
responsible sources
FSC® C016973

Be the first to know about our new releases,
exclusive content and author events by visiting
thamesandhudson.com
thamesandhudsonusa.com
thamesandhudson.com.au